ANIMATION

ROCKPORT

Hereward College
Bramston Crescent
COVENTRY
CV4 9SW

First published in the United States of America by:
Rockport Publishers, Inc.
33 Commercial Street
Gloucester, Massachusetts 01930-5089
Telephone: (978) 282-9590
Facsimile: (978) 283-2742

Distributed to the book trade and art trade in the United States by:
North Light Books, an imprint of
F & W Publications
1507 Dana Avenue
Cincinnati, Ohio 45207
Telephone: (800) 289-0963

Other Distribution by:
Rockport Publishers, Inc.
Gloucester, Massachusetts 01930-5089

ISBN 1-56496-479-5

10 9 8 7 6 5 4 3 2 1

Layout: SYP Design & Production
Select page design by Arisman Design, Charles Brunner, Daniel
Donnelly, The Design Company, and Dutton & Sherman
Cover Image Credits (clockwise from top left): pg.8, pg.60, pg.9,
pg. 16, pg. 49, pg. 43, center pg.15

Manufactured in China

Introduction

Technology is moving in leaps and bounds, and in the world of animation, these advances have drastically increased the potentials. No longer just a Saturday morning entertainment source, animation is making it to the silver screen and to the computer screen. Full-length computer-animated films are a rarity now, but will soon become commonplace. Digitally enhanced films have given filmmakers the chance to create visions only previously possible in their imaginations.

The new accessibility of digital animation has not only affected the entertainment world. With the advent of the World Wide Web, and increased personal computer usage, animation has gained popularity because of its attention-grabbing potential. An animated logo or interactive interface will keep the viewer's interest and attention longer than a static image. *Design Library: Animation* explores some of these new uses, and should provide endless inspiration for today's designers.

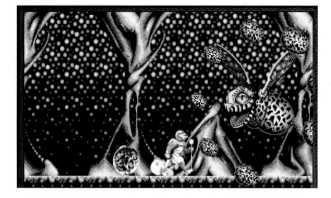

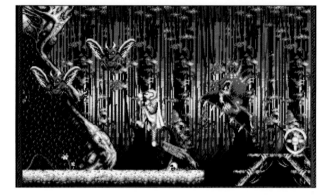

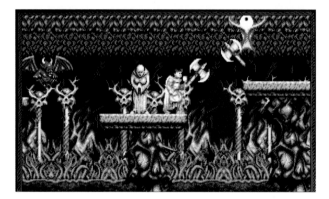

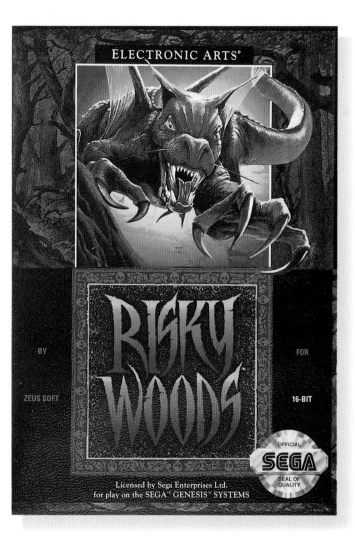

RISKY WOODS™

Company
Electronic Arts

Design Firm
13th Floor

Art Director
Nancy Fong, Nancy Waisanen

Designer
Dave Parmley

Computer Production
Matt Hendershot, Stover Pix

Creature illustration was adapted from United Kingdom game package. The art was scanned and recreated in Adobe Photoshop. On the package back the graphics feature a map created in Adobe Photoshop to add to the element of adventure. Cover and back graphics and type were assembled in Quark.

DIFFERENT DRUMMER

Design and Editorial Company
Two Headed Monster

Production Company
Smillie Films

Client
Tele-Communications, Inc.

Agency
Red Ball Tiger, San Francisco

Art Director/Designer
David J. Hwang

Live Action Director
Peter Smillie

Editor
Christopher Willoughby

Executive Producer
Ruth Schiller

Design Assistant
Treena Loria

Red Ball Tiger Producer
Carey Crosby

Software Used
Henry, Adobe Photoshop and Illustrator

Hardware Used
Power Mac, Silicon Graphics, Inc., Indigo 2 and Onyx

Design Firm:
Socio X

Editors and Publishers:
Kim Hastreiter, David Hershkovits

Creative Director:
Bridget deSocio

Designers:
Lara Harris, Mayra Morrison, Greg Smith

Producer:
Noah Koff

Copy:
Angela Tribelli, Shana Liebman

Programmers:
Michael Rais, Larry Yudelson

Advertising Executive:
Jonathan Landau

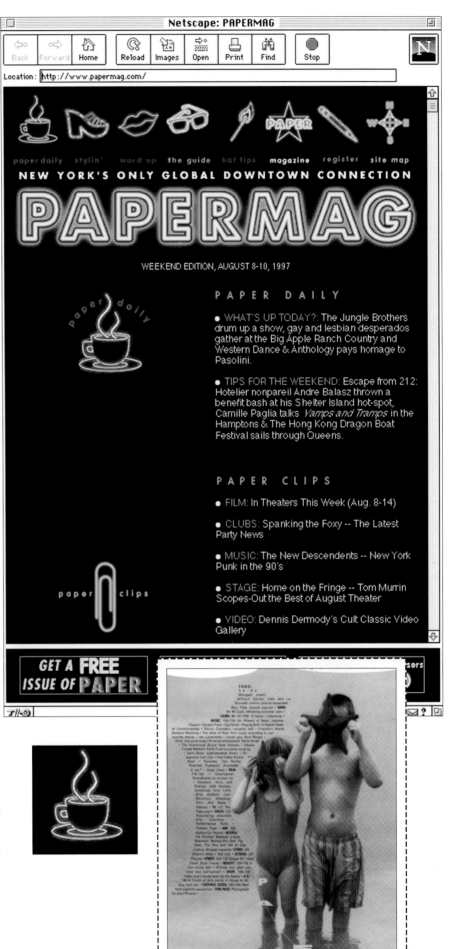

Hardware:
Macintosh

Software:
Photoshop, Premiere, Illustrator, BBEdit, SoundEdit 16

Typeface:
Futura Bold

Special Features:
GIF89a animation, JavaScript, QuickTime video, WAV audio

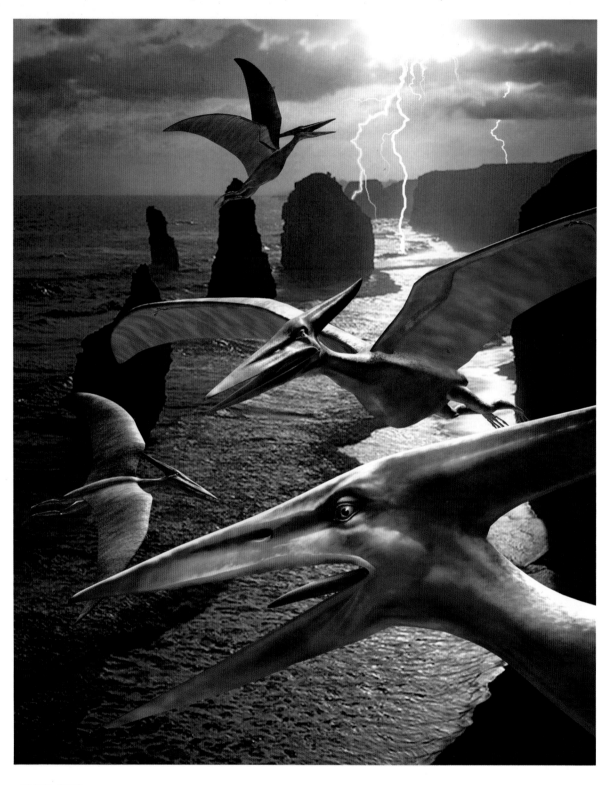

DEMO REEL

Animation Studio
Mike Efford 3-D Animation

Character Creator/Designer
Mike Efford

Editor
Scott Broad, The Post Shop

Software Used
NewTek Lightwave, Adobe
Photoshop

Hardware Used
Pentium Processor, Windows NT

Pterodactyls were modeled using
Lightwave 3.5, image processed
using Photoshop 2.5 and composited
onto a Corel Photo Background,
extensively reworked.

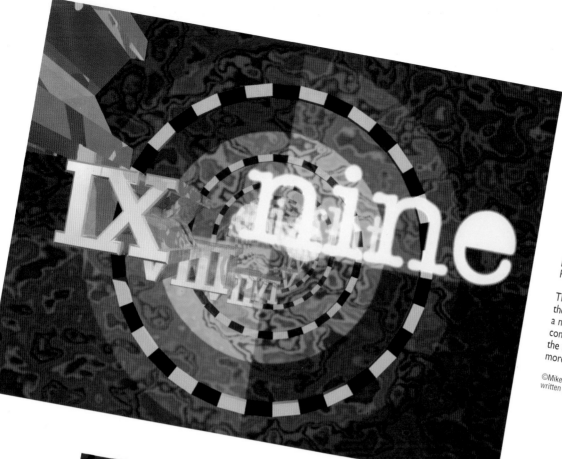

DEMO REEL

Animation Studio
Mike Efford 3-D Animation

Character Creator/Designer
Mike Efford

Editor
Scott Broad, The Post Shop

Software Used
NewTek Lightwave

Hardware Used
Pentium/Windows NT

This countdown sequence is from the animator's 1996 demo reel. It is a new spin on an old theme. The concept here is the contrast between the relentless march of time, and its more fleeting fragile aspects.

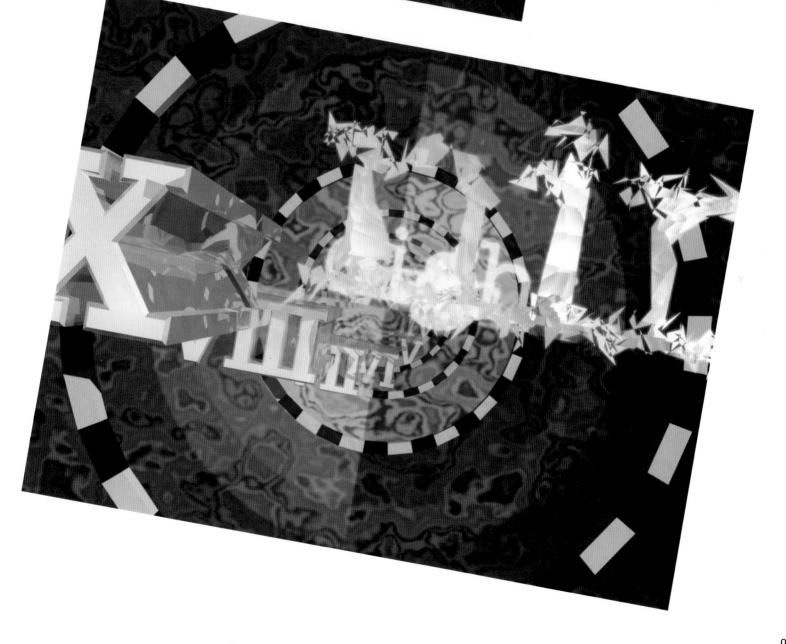

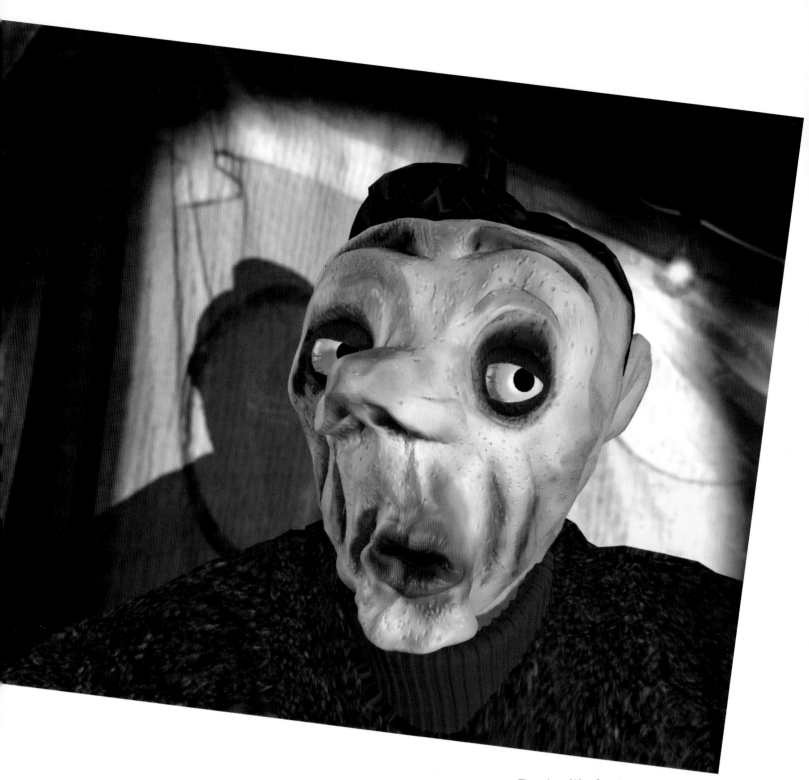

The pathos of life reflects in the face of the Barker, a character in Lamb & Company's *Huzzah—Babaloo the Beast Boy*, proving that computer animation can truly touch heart and soul.

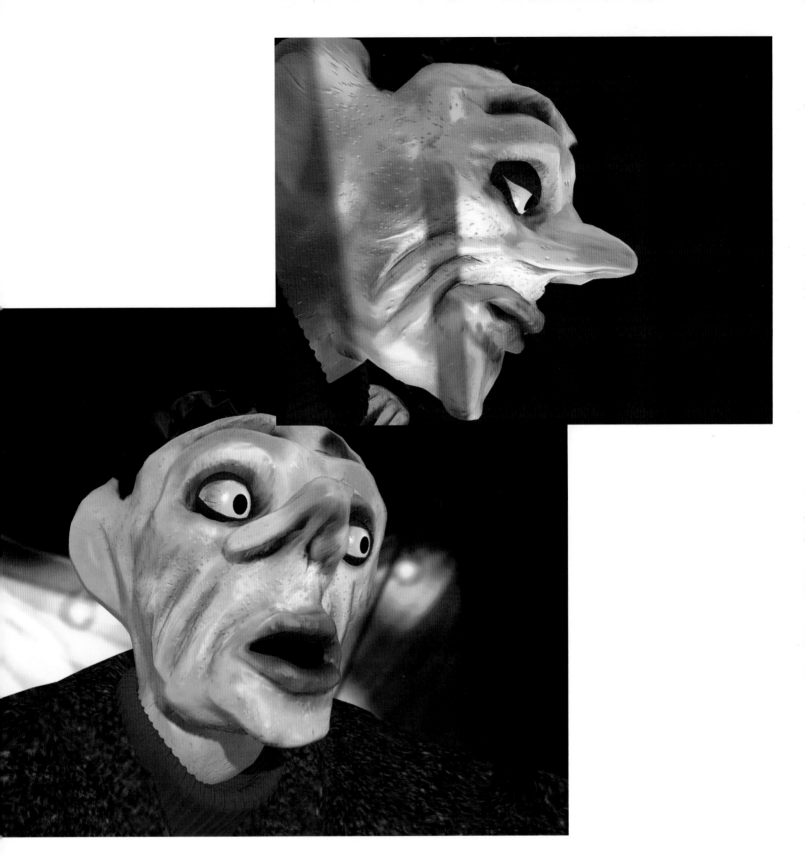

". . . watch him heal the sick, bring hope to the lost. You'll
scream. You'll shout. You'll laugh so hard your lips will
touch behind your head. All for one thin dime. One tenth
of a dollar . . . Huzzah . . . Huzzah"

—from Lamb & Company's *Huzzah—Babaloo the Beast Boy*

WHAT A CARTOON! SHOW
TELEVISION GRAPHICS

Design/Editorial Company
Two Headed Monster

Name of Client
The Cartoon Network

Designer/Director
David J. Hwang

Technical Director
David J. Hwang

Executive Producer
Ruth Schiller

Producer
Jennifer Lucero

Assistant Designer
Dana Walbaum

Software Used
Flint, Henry, Adobe Illustrator
and Photoshop

Hardware Used
Power Mac, Silicon Graphics,
Inc. Indigo 2 and Onyx

Designer David Hwang used
Photoshop and Illustrator to design
400 candy-colored still frames for
the opening of the Cartoon
Network's "What a Cartoon!
Show". Hwang manipulated
existing footage of new and historical
Cartoon Network characters and
then composited the images.

TECHNIQUE: In issue 1.05 of nrv8 the designer created a running dialog presented as a GIF89a animation created with GifBuilder and Photoshop. Shown below are three frames of the larger animation, in which the issue's title and date rotate and bitmapped text set at three separate angles loops as an animation, repeating until the viewer clicks to continue into the 'zine.

The absence of our contemplation of loneliness

is but one of the symptons of our widespread

regression into a culture of denial.

Project
nrv8

Designer
Edwin Chang

Authoring Program
GIF89 animation, Live Audio, Java Script

BILL DOMONKOS

SELF-PROMOTION

Netscape: B Domonkos Home

Back | Forward | Home | Reload | Images | Open | Print | Find | Stop

Location: http://www.bdom.com/documents/homepage.html

Netscape: Bill Domonkos

Back | Forward | Home | Reload | Images | Open | Print | Find | Stop

Location: http://www.bdom.com/

Bill Domonkos, a freelance designer and animator based in San Francisco, crafted this online portfolio of his work to surprise viewers, thereby also engaging them. The site is almost wholly image-based, text being restricted to the splash page (top right) and the designer's biography area. Viewers to the site are compelled to explore a language-less land with their sole reward being visual imagery. Clicking on one image leads to other surreal images, as well as to Shockwave interactive pieces.

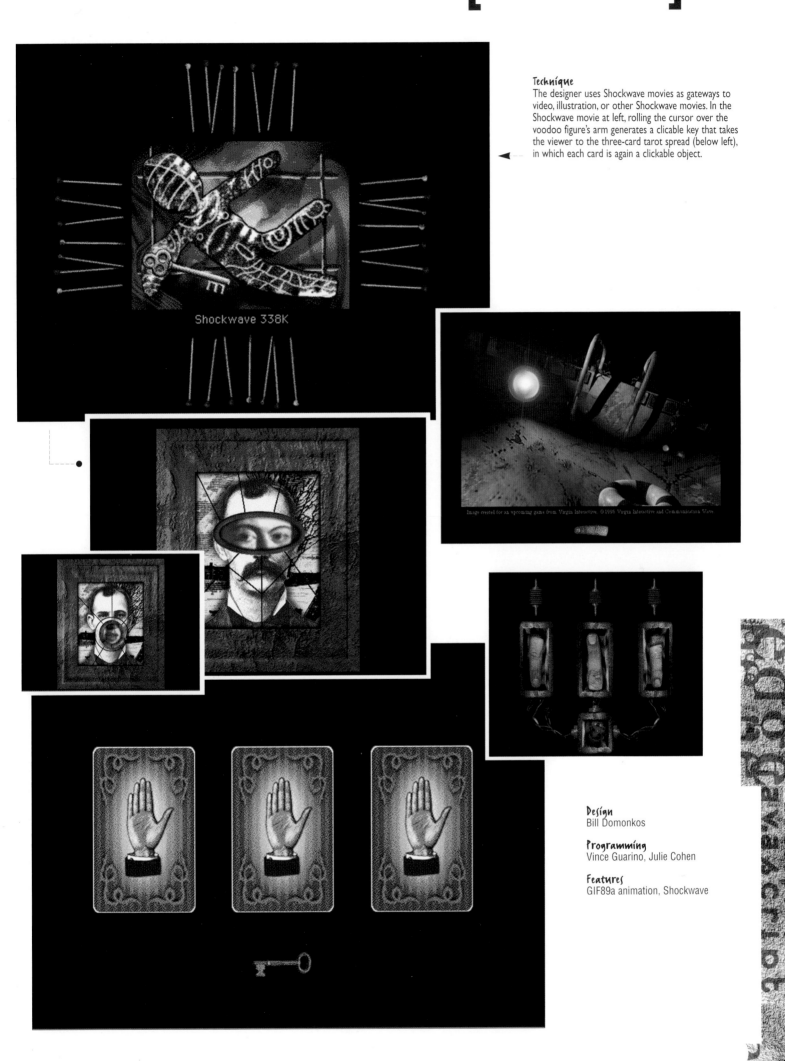

Technique
The designer uses Shockwave movies as gateways to video, illustration, or other Shockwave movies. In the Shockwave movie at left, rolling the cursor over the voodoo figure's arm generates a clicable key that takes the viewer to the three-card tarot spread (below left), in which each card is again a clickable object.

Shockwave 338K

Image created for an upcoming game from Virgin Interactive. ©1996 Virgin Interactive and Communication Wave.

Design
Bill Domonkos

Programming
Vince Guarino, Julie Cohen

Features
GIF89a animation, Shockwave

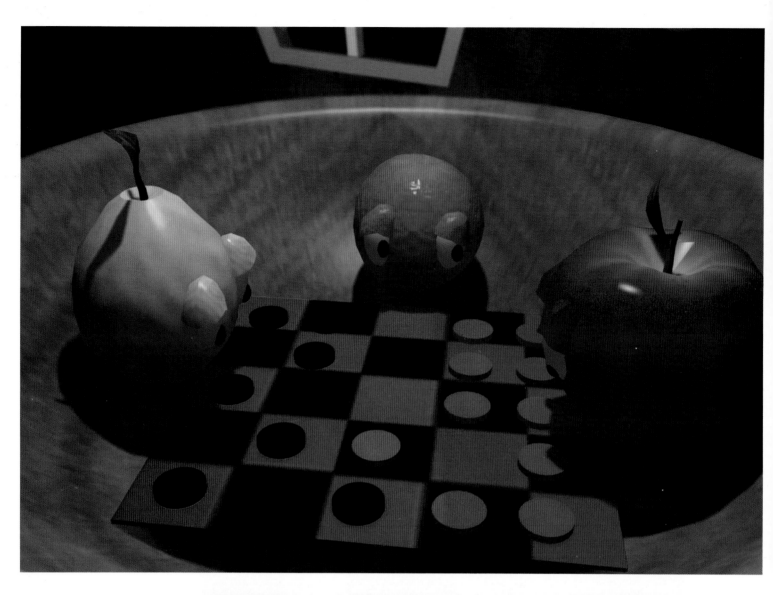

MTV FRUIT CHECKERS
COMMERCIAL

Animation Studio
Happy Boy Pat

All Design and Animation
Patrick A. Gehlen

Software Used
auto•des•sys Inc. form•Z,
ElectricImage Animation System,
Adobe Photoshop

Hardware Used
Power Macintosh

The animation was modeled in
form•Z, textured using Photoshop,
and animated and rendered using
ElectricImage.

© 1996 Patrick A. Gehlen

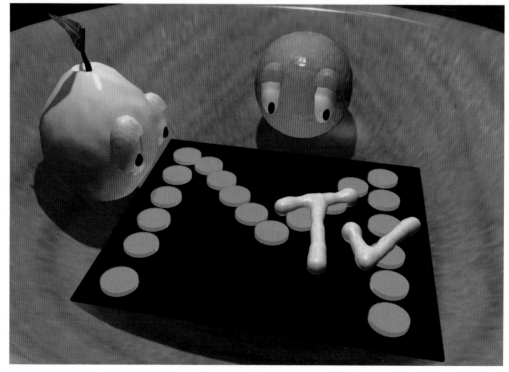

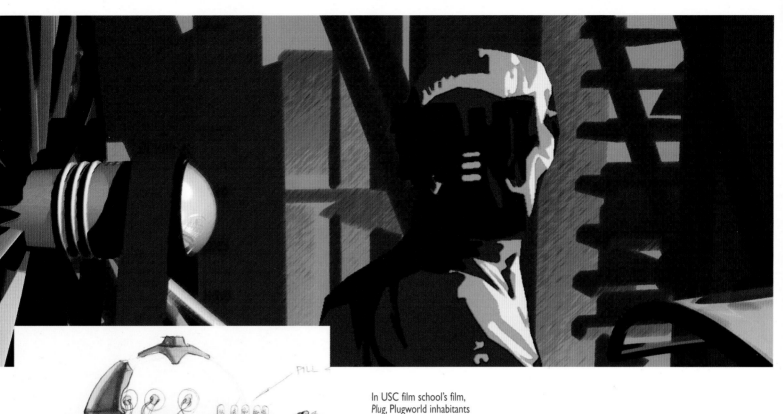

In USC film school's film, *Plug*, Plugworld inhabitants struggle to maintain a physical connection between outlet towers and the extension cords they carry in portable backpacks that hook into their brainstems. When they're not "plugged" in, reality changes form.

Previsualization backgrounds show a world devoid of human comforts.

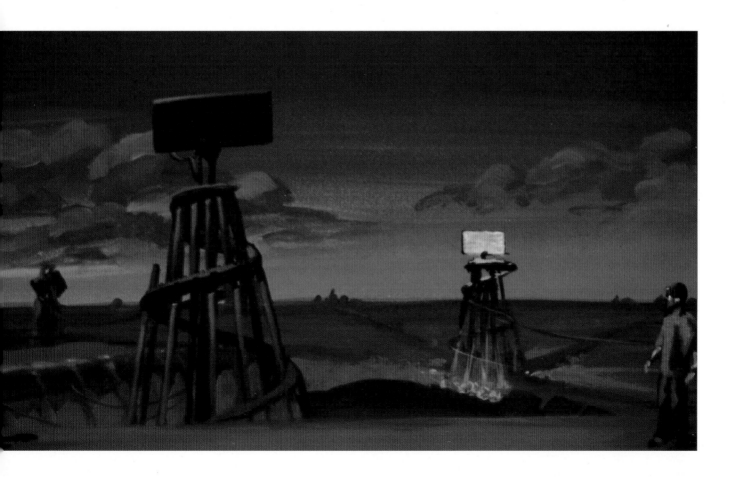

The filmmakers' careful work in pre-production paid off. The finished product looks exactly like their storyboards.

"It's sort of like a little worm that's instructed to move forty pixels and then draw a line from the place it started to the place it stops," Gourjian says.

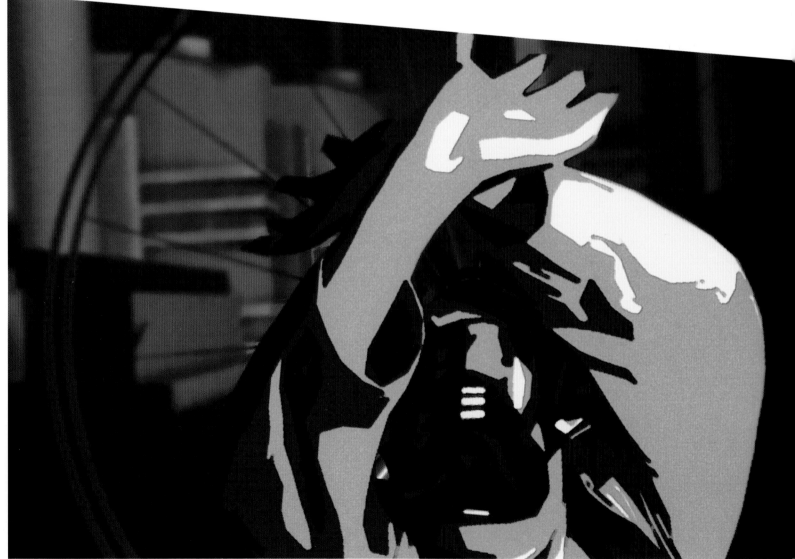

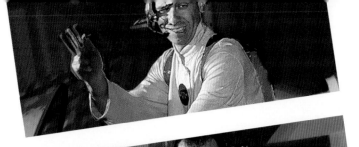

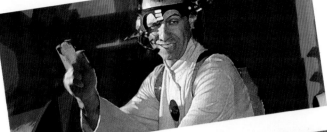

Jamie Waese morphs
from live-action hero to
a cartoon in Plug, by
USC Film School.

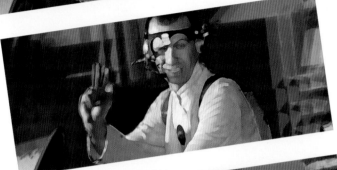

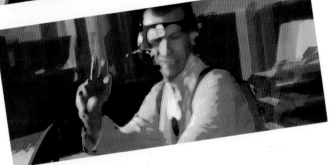

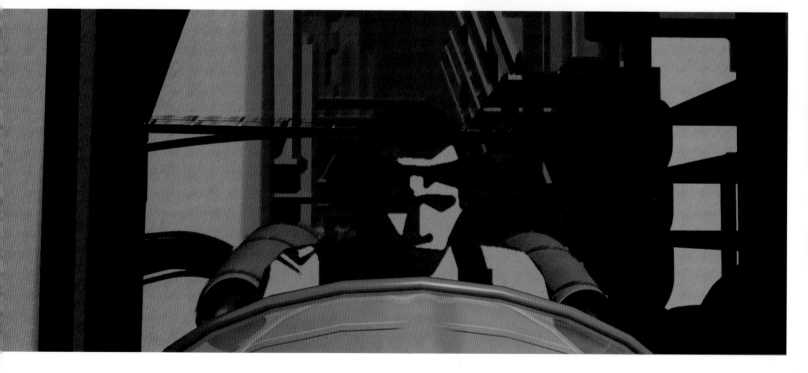

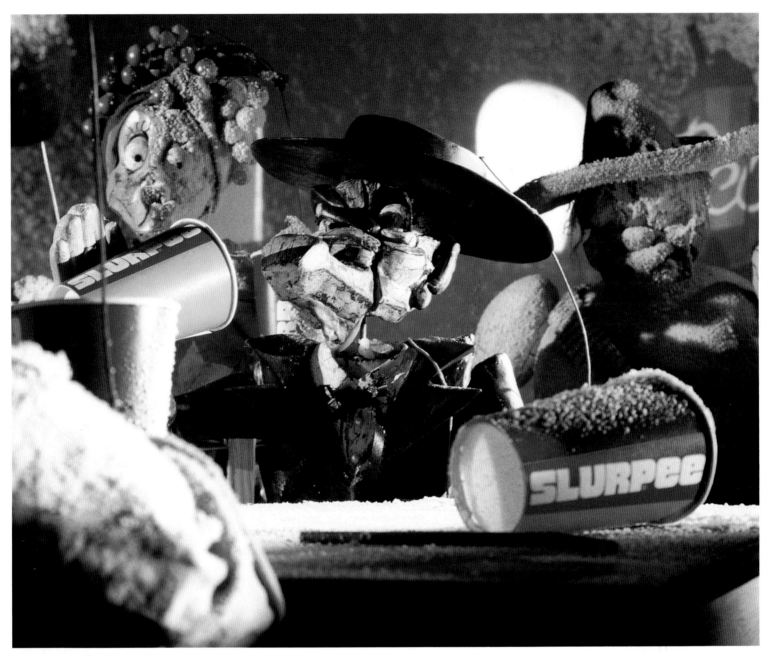

STAND OFF

Animation Studio
Olive Jar Studios

Client/Agency
The Southland Corporation,
J. Walter Thompson (Chicago)

Creative Director
Fred MacDonald

Supervising Animator
Rich Ferguson-Hull

Technical Director
Bryan Papciak

Directors
Fred MacDonald, Rich Ferguson-
Hull, Bryan Papciak

Producer
Jim Moran

Executive Producer
Matthew Charde

Software Used
Quantel Henry

(*opposite page*)

Design Firm
Socio X

Editors and Publishers
Kim Hastreiter, David Hershkovits

Creative Director
Bridget deSocio

Designers
Lara Harris,
Mayra Morrison, Greg Smith

Producer
Noah Koff

Copy
Angela Tribelli, Shana Liebman

Programmers
Michael Rais, Larry Yudelson

Advertising Executive
Jonathan Landau

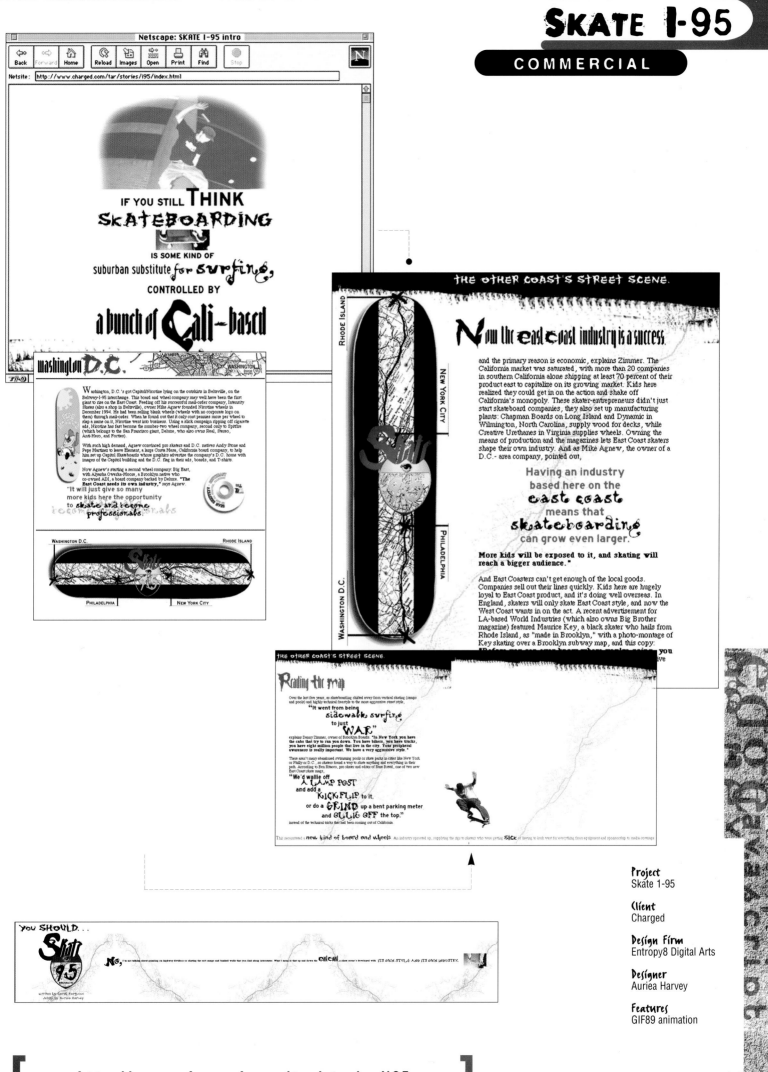

Project
Skate 1-95

Client
Charged

Design Firm
Entropy8 Digital Arts

Designer
Auriea Harvey

Features
GIF89 animation

BAU-DA DESIGN LAB INC

SELF-PROMOTION

The Bau-Da Design Lab Inc. Website displays simplicity with an edge. Bold, retro typography, an old-fashioned vacuum tube image, and a basic color scheme combine to demonstrate a clear sense of style and confidence.

The splash page sequence to the right shows how the "Design-o-matic" logo is animated using two halves of a butterfly shape. JavaScripting allows the Bau-Da vacuum tube to cycle through two glow levels as though heating up and cooling down. Viewers click on the tube to link to the home page, below.

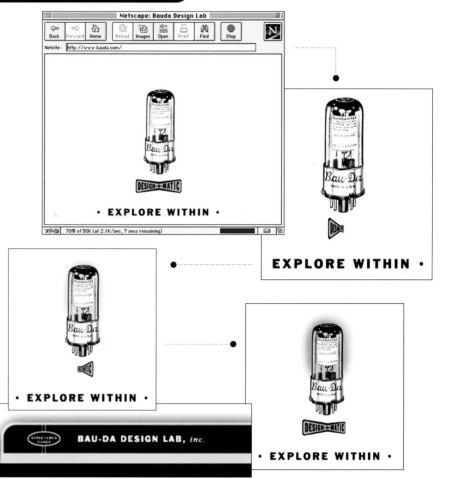

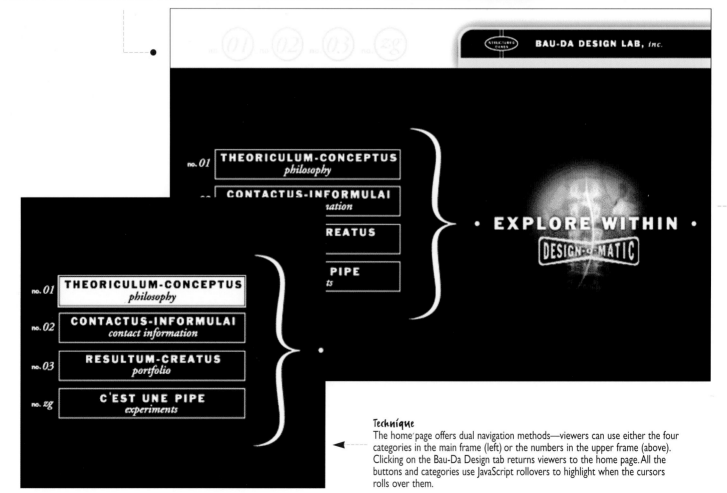

Technique
The home page offers dual navigation methods—viewers can use either the four categories in the main frame (left) or the numbers in the upper frame (above). Clicking on the Bau-Da Design tab returns viewers to the home page. All the buttons and categories use JavaScript rollovers to highlight when the cursors rolls over them.

MILK MOB (NABISCO)
television advertisement

studio
Bear Spots Inc.

designer
Shawn Seles

supervisors/directors
Clive Smith, Joseph Sherman

supervisor/animator
Shawn Seles

art directors
Clive Smith, Joseph Sherman

advertisement agency
Bozell Jacobs Toronto

Live action and table top pixilation composited with cel animation.

MONSTERS IN MY POCKET (NABISCO)
television advertisement

studio
Bear Spots Inc.

designer
Shawn Seles

supervisor/director
Joseph Sherman

supervisor/animator
Shawn Seles

art director
Joseph Sherman

Traditional cel animation.

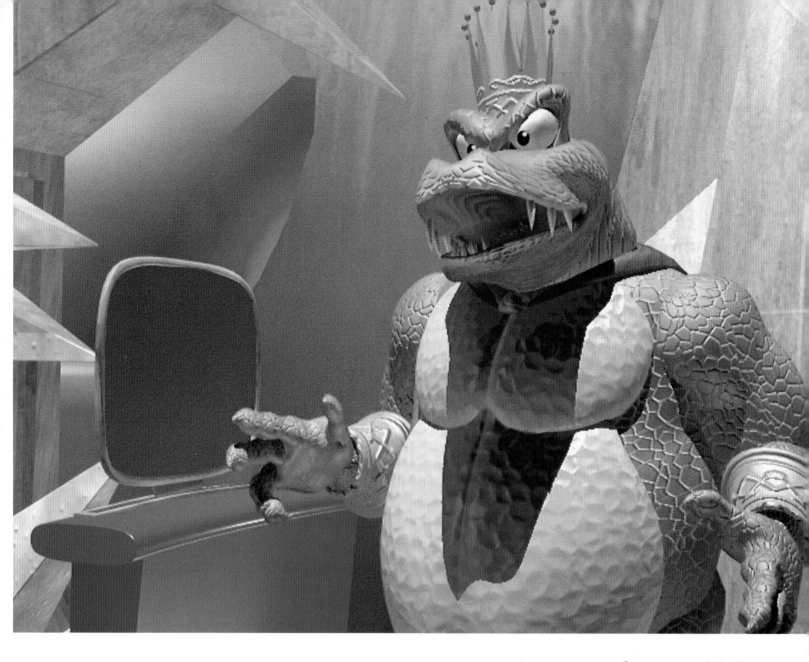

One crown not enough? King K Rool and his evil reptilian minions are out to steal Donkey Kong's crown, in Medialab's *Donkey Kong Country*.

POTATOMAN VIBRATIONS
PART I
SHORT FILM

Animation Studio
Hop-To-It Graphics

**Character Creator/Designer/
Supervisor/Animator/
Technical Director/Director**
Carol J. Baker

Software Used
Fractal Design Ray Dream Studio,
Avid Videoshop

Hardware Used
Macintosh

This is an image rendered from
a music video featuring the
"Scary Potatoes" around the
song "El Hambre Del Hombre
Del Papa Abajo."

©1996 C.J. Baker

POTATOMAN VIBRATIONS
PART II
SHORT FILM

Animation Studio
Hop-To-It Graphics

**Character Creator/Designer/
Supervisor/Animator/
Technical Director/Director**
Carol J. Baker

Software Used
Fractal Design RayDream Studio,
Avid Videoshop

Hardware Used
Macintosh

The animation was designed to fit
the lilting rhythm of the song
"Breakfast Beer Takes Effect to
Navigate the Potatoes Through
a Barrage of Meteors."

©1996 C.J. Baker

**POTATOMAN VIBRATIONS
PART III**
SHORT FILM

Animation Studio
Hop-To-It Graphics

**Character Creator/Designer/
Supervisor/Animator/
Technical Director/Director**
Carol J. Baker

Software Used
Fractal Design Ray Dream Studio,
Avid Videoshop

Hardware Used
Macintosh

The animator used the magical
sounds of the electric piano as
performed by one of the potatoes
as an influence in the theme of
this work.

**POTATOMAN VIBRATIONS
PART IV**
SHORT FILM

Animation Studio
Hop-To-It Graphics

**Character Creator/Designer/
Supervisor/Animator/
Technical Director/Director**
Carol J. Baker

Software Used
Fractal Design Ray Dream Studio,
Avid Videoshop

Hardware Used
Macintosh

The Potatoes were hypnotized by
the magical music emanating from
the spaceship star song and are on
a collision course with the Earth.

THE FLINTSTONES® GENESIS™

Company
Ocean®

Design Firm
Ocean

Art Director
Adrian Ludley, Alan Pashley

Programmer
Mark Rogers, Paul Robinson

Illustrator
Steve Kerry, Bart McLaughlin

The design captures the distinct look and feel of the film through the use of actual sound bites from the movie, and true character likenesses of all the stars. The cartoon quality graphics and animation, and the many levels of deep and diverse gaming make this colorful game fun for the whole family.

Objective
Gamers play in a cartoon world filled with stunning graphics, hilarious animation sequences, and all the movie's zany characters and icons. The objective is to lead Fred Flintstone through 45 levels of danger, dinosaurs, and jungle.

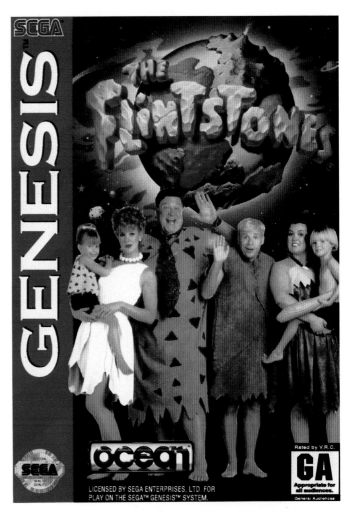

ADDAMS FAMILY® VALUES

Company
Ocean®

Design Firm
Ocean

Art Director
Don McDermott,
John Hackleton

Programmer
Rob Walker, Phil Trelford,
John May, David Chiles

Musician
Keith Tinman

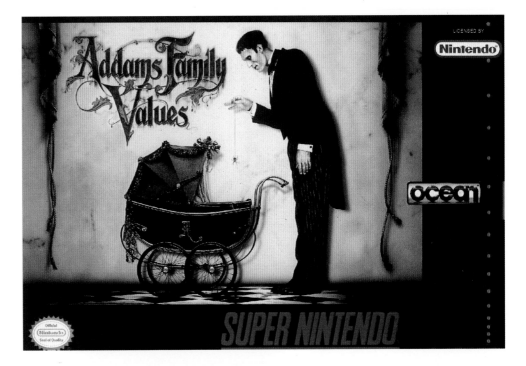

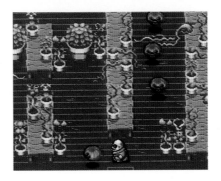

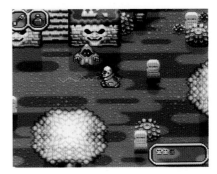

27

URL: http://www.electric.co.za

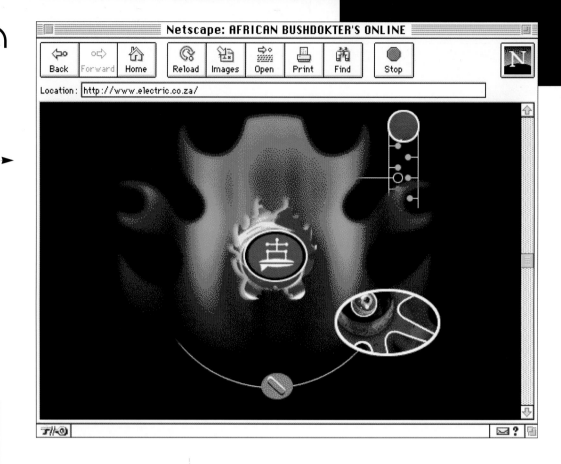

Netscape: AFRICAN BUSHDOKTER'S ONLINE

Location: http://www.electric.co.za/

SELF-PROMOTION

Electric Ocean's portfolio Website begins with a unique, invitingly illustrated splash page. There is no text, only a blinking red animated GIF circle at the top right and an inset eyeball graphic that foreshadows the contents page illustration.

The contents page is just as simplistic as the splash page. Only four links lead from this page: (right) to "contact" informaton, "hype" about the company's various projects, a client's page, and a biographical page.

It's simplicity combined with the beautifully rendered graphics that draws the viewer into the site.

The color scheme works well with the black background, and images are optimized for quick download, without being overly compressed and pixellated.

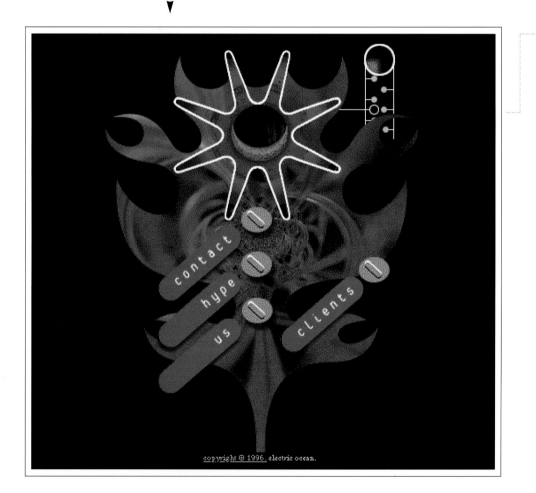

copyright © 1996, electric ocean.

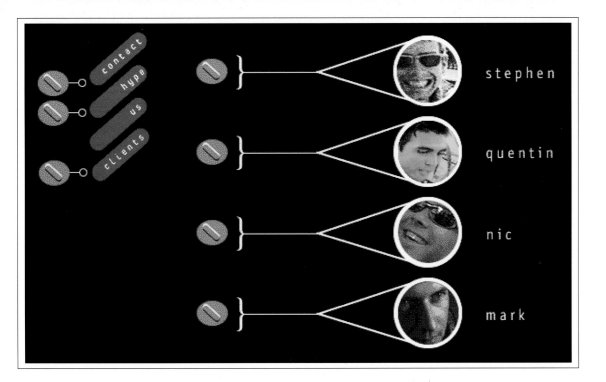

 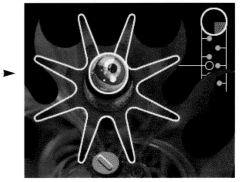

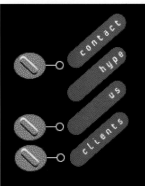

STUDIO ONE AWARD *(Internet Professional Publishers Association)*
"After an in-depth review, your studio has been selected for the IPPA's StudioONE Award, saluting the finest advertising and Web design agencies working on the Internet today. The StudioONE Award focuses corporate interest on quality design agencies, increases the marketing potential of those agencies, and serves to honor and reward quality work by directly recognizing the individual agencies rather than strictly a few of their best sites."
Thomas Van Hare, president of the IPPA

LOERIE AWARDS (South Africa) June 10 1996.
"Electric Ocean (1996 Loerie winner in the promotional marketing category) wins the first major ad award for a net site."

Project: Electric Ocean Portfolio
Design firm: Electric Ocean
Designer: Nicholas Wittenberg
Illustrator: Nicholas Wittenberg
Programmer: Stephen Garratt
Features: GIF89a animation

Lamb & Company brings digital life to every family's favorite boardgame in this :30 spot called *Plastic People*.

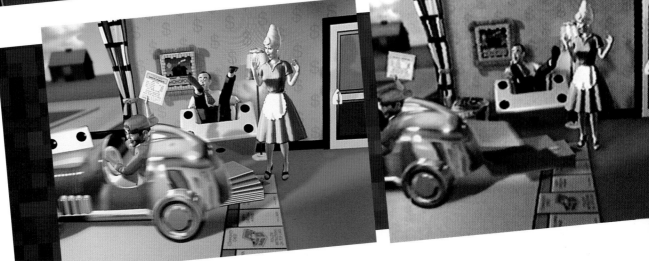

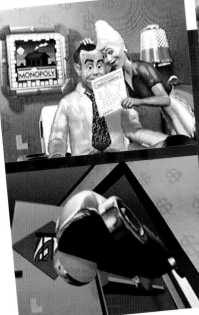

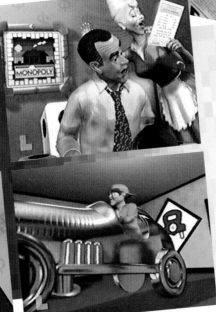

Here Mom tries to get Dad to loan her some dough, while junior smashes through the front door in his racer car game piece.

Plastic People shows off Lamb & Company's ability to create realistic human movement under the tight deadlines of the commerical industry.

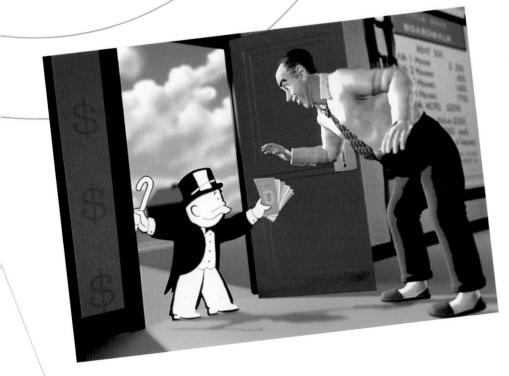

The Monopoly Man brings Dad the good news, a $100 inheritance.

Macromedia's Website should be bookmarked in every multimedia designer's browser, especially now that the Shockwave plug-in, which works with Netscape to play Macromedia Director animations, is available. With its wealth of information, coupled with an attractive interface, this site is helping set the course for future multimedia design.

The intro screen to Macromedia's contents page uses the Shockwave plug-in to create a slot-machine-like effect (including sound) as images roll into place. The "hot contents" button then cycles through an animation of a flame until the viewer clicks to go to the main contents page.

The designers of Macromedia's site have done an exceptional job of combining an extensive database of information with a graphical interface. Icons identify all of the main sections and are repeated on subsequent links, and each section is color-coded to facilitate navigating the site.

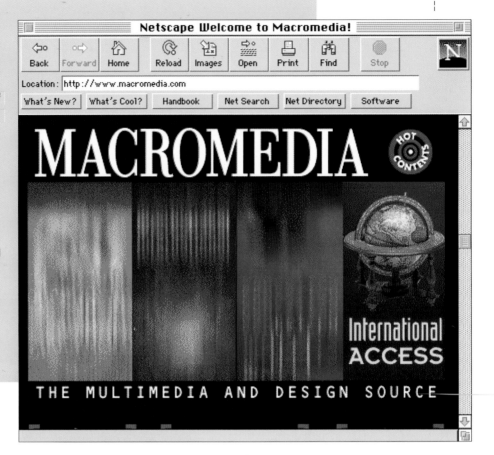

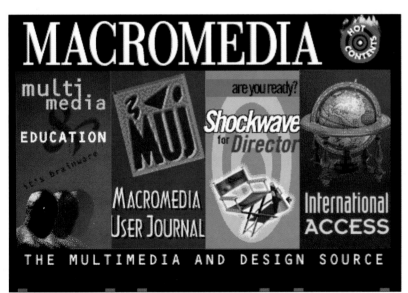

Project: Macromedia Website

Design Firm: Macromedia

Designers: Macromedia Staff

Authoring Program: HTML

Platform: Browser Related

URL: http://www.macromedia.com
Copyright © Macromedia, Inc. 1995.
Used with permission.

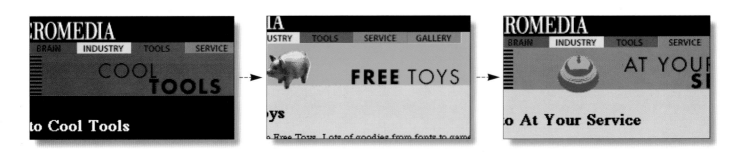

O.K. OIL
SHORT FILM

Animation Studio
National Animation and
Design Centre

Character Creator/Designer
Deak Ferrand

Supervisor/Animator
Deak Ferrand

Technical Director
Robin Tremblay

Director
Deak Ferrand

Software Used
Microsoft Softimage

Hardware Used
Silicon Graphics, Inc., Extreme

©Centre NAD

KITCHEN STORY
SHORT FILM

Animation Studio
National Animation and
Design Centre

Character Creator/Designer
Martin Lauzon

Supervisor/Animator
Martin Lauzon

Technical Director
Robin Tremblay

Director
Martin Lauzon

Software Used
Microsoft Softimage

Hardware Used
Silicon Graphics Inc. Extreme

©Centre NAD

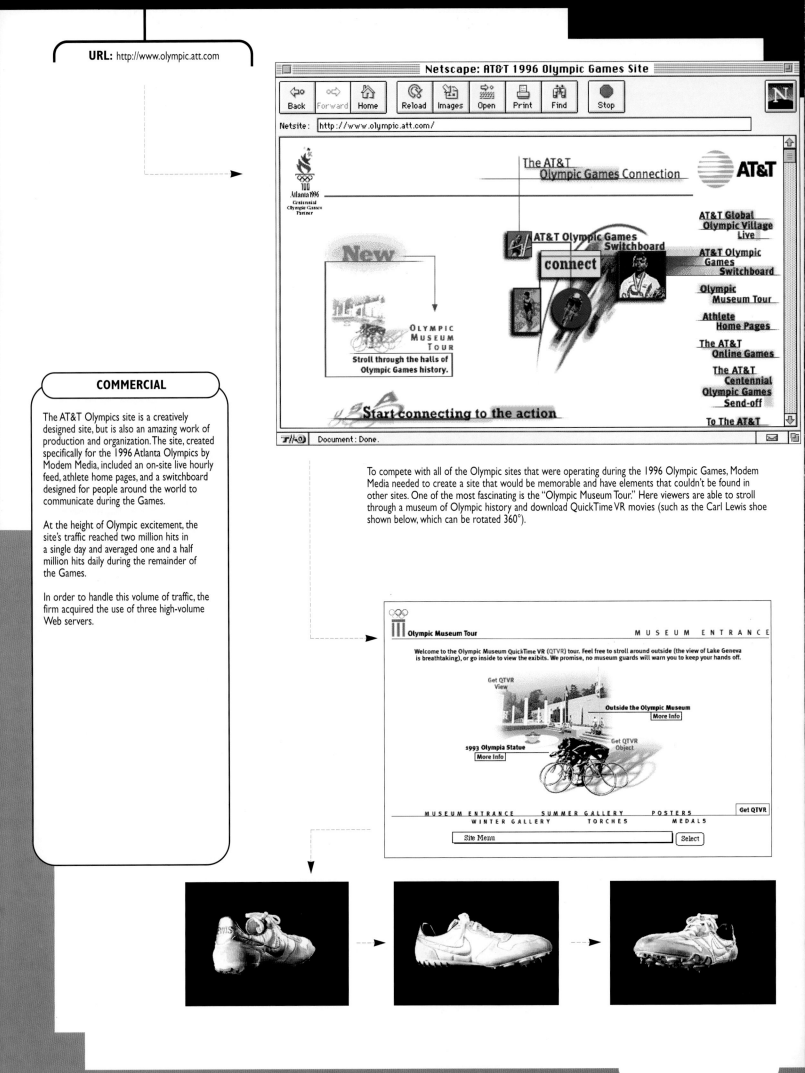

Netscape: AT&T 1996 Olympic Games Site

Back | Forward | Home | Reload | Images | Open | Print | Find | Stop

Netsite: http://www.olympic.att.com/

The AT&T Olympic Games Connection

AT&T

Atlanta 1996
Centennial
Olympic Games
Partner

New

AT&T Olympic Games Switchboard

connect

OLYMPIC MUSEUM TOUR
Stroll through the halls of Olympic Games history.

Start connecting to the action

AT&T Global Olympic Village Live

AT&T Olympic Games Switchboard

Olympic Museum Tour

Athlete Home Pages

The AT&T Online Games

The AT&T Centennial Olympic Games Send-off

To The AT&T

Document: Done.

COMMERCIAL

The AT&T Olympics site is a creatively designed site, but is also an amazing work of production and organization. The site, created specifically for the 1996 Atlanta Olympics by Modem Media, included an on-site live hourly feed, athlete home pages, and a switchboard designed for people around the world to communicate during the Games.

At the height of Olympic excitement, the site's traffic reached two million hits in a single day and averaged one and a half million hits daily during the remainder of the Games.

In order to handle this volume of traffic, the firm acquired the use of three high-volume Web servers.

To compete with all of the Olympic sites that were operating during the 1996 Olympic Games, Modem Media needed to create a site that would be memorable and have elements that couldn't be found in other sites. One of the most fascinating is the "Olympic Museum Tour." Here viewers are able to stroll through a museum of Olympic history and download QuickTime VR movies (such as the Carl Lewis shoe shown below, which can be rotated 360°).

Olympic Museum Tour MUSEUM ENTRANCE

Welcome to the Olympic Museum QuickTime VR (QTVR) tour. Feel free to stroll around outside (the view of Lake Geneva is breathtaking), or go inside to view the exibits. We promise, no museum guards will warn you to keep your hands off.

Get QTVR View

Outside the Olympic Museum
More Info

1993 Olympia Statue
More Info

Get QTVR Object

Get QTVR

MUSEUM ENTRANCE SUMMER GALLERY POSTERS
 WINTER GALLERY TORCHES MEDALS

Site Menu Select

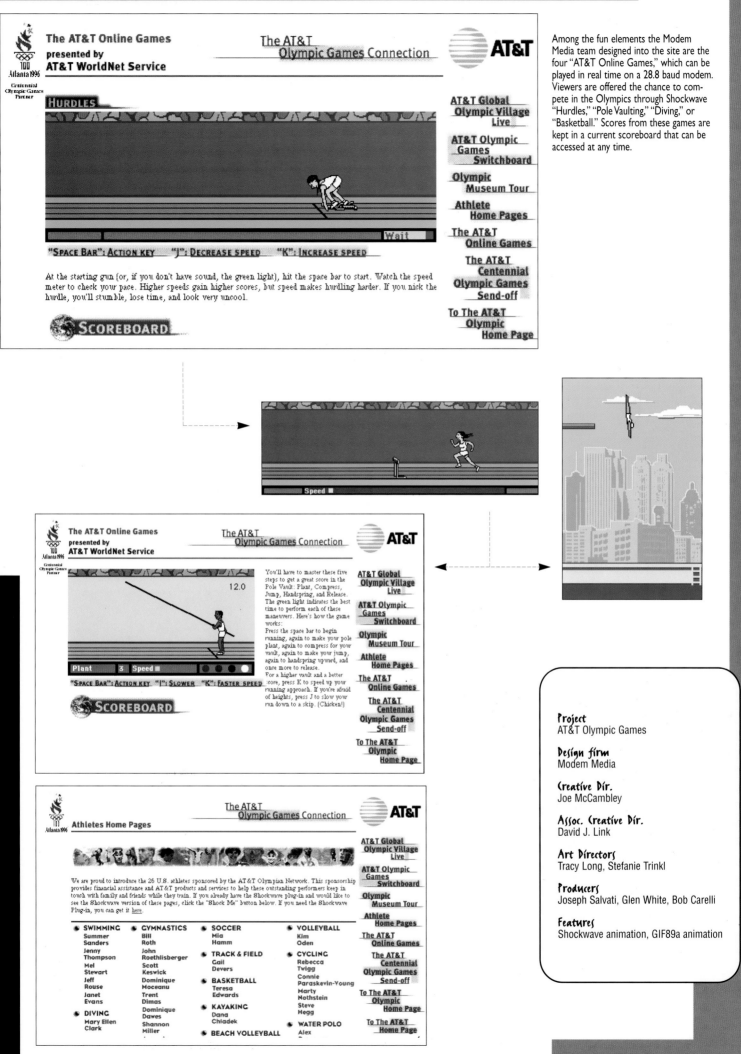

Among the fun elements the Modem Media team designed into the site are the four "AT&T Online Games," which can be played in real time on a 28.8 baud modem. Viewers are offered the chance to compete in the Olympics through Shockwave "Hurdles," "Pole Vaulting," "Diving," or "Basketball." Scores from these games are kept in a current scoreboard that can be accessed at any time.

Project
AT&T Olympic Games

Design firm
Modem Media

Creative Dir.
Joe McCambley

Assoc. Creative Dir.
David J. Link

Art Directors
Tracy Long, Stefanie Trinkl

Producers
Joseph Salvati, Glen White, Bob Carelli

Features
Shockwave animation, GIF89a animation

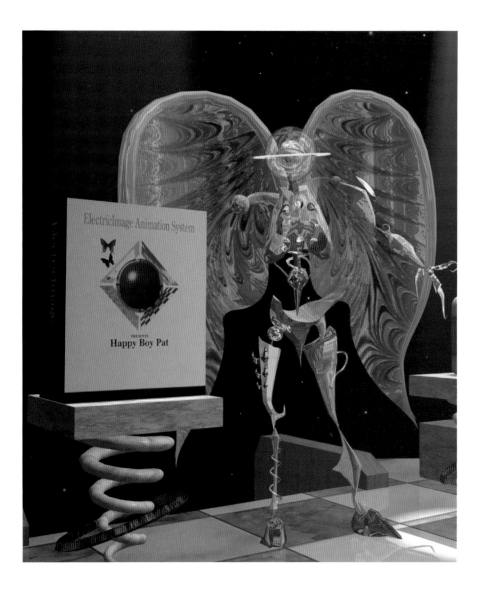

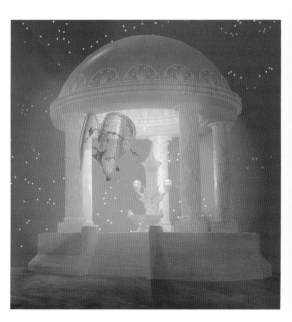

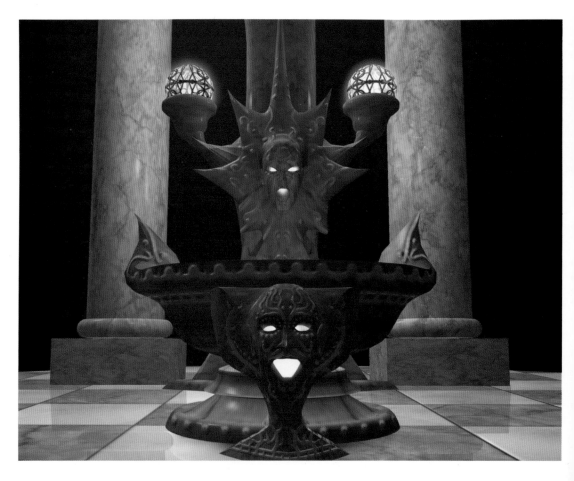

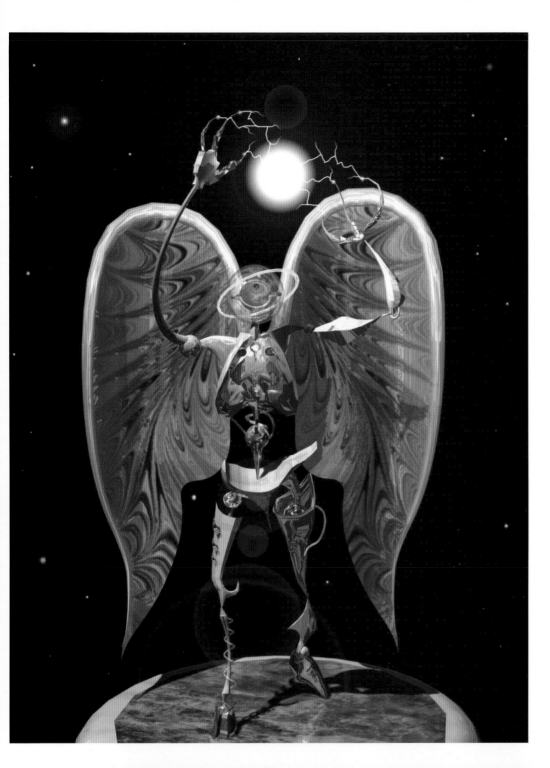

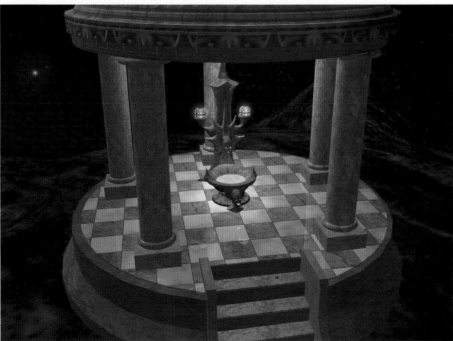

ELECTRIC IMAGE
DEMO REEL

Animation Studio
Happy Boy Pat Studios

All Design and Animation
Patrick A. Gehlen

Software Used
ElectricImage Animation System,
Adobe Photoshop, Hash, Inc.
Animation Master, Media Paint,
auto•des•sys Inc. form•Z

Hardware Used
Power Macintosh

The fountain was sculpted in
MH3-D, and then brought into the
twilight realm of Cyber Angel and his
temple on the hill. The textures were
done in Photoshop.

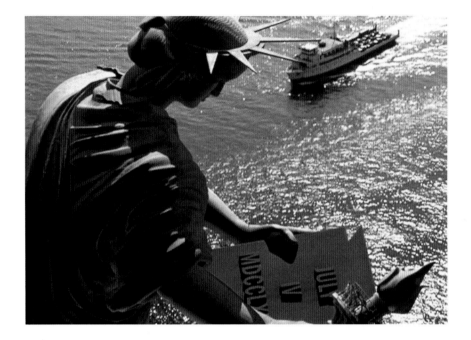

OLDSMOBILE AURORA
CAUGHT THEIR EYE

Animation Studio
R/Greenberg Associates

Client/Agency
Oldsmobile/Leo Burnett
Company, Inc.

Computer Graphics Animators
Eileen O'Neill, David Barosin,
Jason Strougo, Jim Hundertmark,
Steve Blakey, John Musumeci

Technical Director
Henry Kaufman

Visual Effects Supervisor
Ed Manning

Director of Computer Graphics
Mark Voelpel

Software Used
Microsoft Softimage, R/GA
proprietary software

Hardware Used
Silicon Graphics, Inc.

To recreate a realistic image, they
began by filming a woman dressed
as the statue walking through a
2,000 gallon tank and holding a
miniature of the Aurora. This was
followed by an on-location shoot in
New York Harbor. R/GA created
three-dimensional computer models
of the statue, her robe, and torch for
a total of 31 shots. R/GA finished the
commercial by compositing the
computer-generated and live-action
images via its component D-1
digital video.

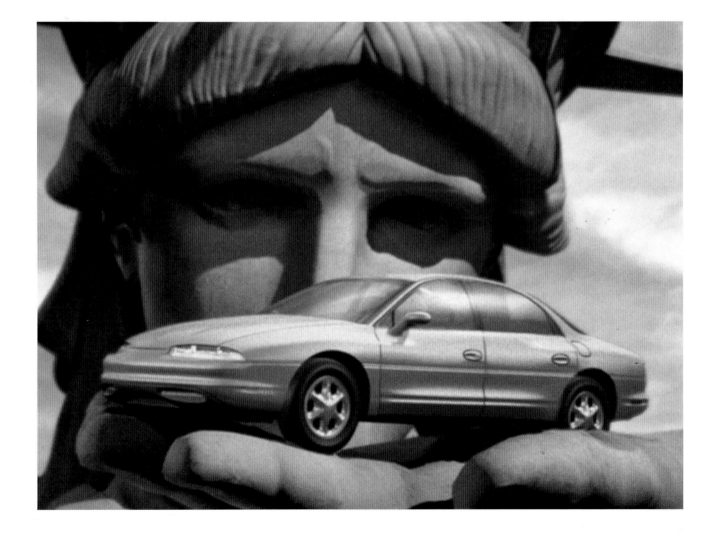

PDI wakes up the industry with *The Sleepy Guy*.

Lamb & Company brings a theatrical twist to motion capture in *Huzzah— Babaloo the Beast Boy*.

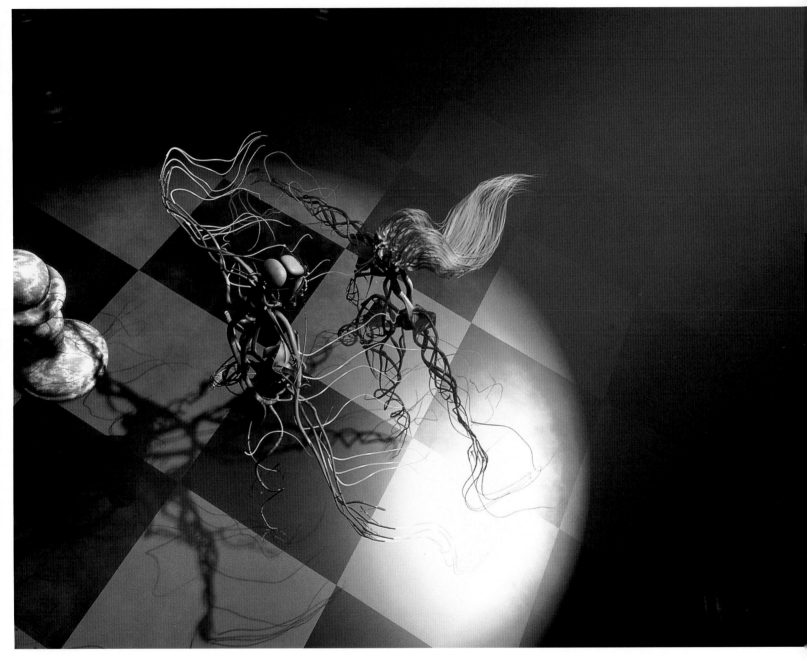

A scene from Alias/Wavefront's *the end*.

The feel of speed is created by varying the distance between the tracks and the surrounding environments. The closer the walls appear, the faster the ride seems to go.

This clip from New Wave International's *Thrill Ride— The Science of Fun* shows the difference in film formats. The postage stamp-size image is 35mm. The larger image is 15 perf/70mm.

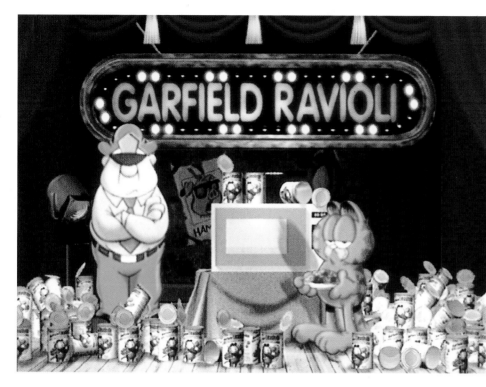

SURPRISE PARTY (GARFIELD RAVIOLI)
television advertisement

studio
Bear Spots Inc.

designer
Shawn Seles

supervisor/director
Shawn Seles, Clive Smith

supervisor/animator
Shawn Seles

art director
Shawn Seles

cgi artists
Fred Luchetti, Peter Hudecki

Cel animated characters composited with a three-dimensional computer-generated environment.

GARFIELD: HIS 9 LIVES OR GARFIELD'S FELINE FANTASIES
television special

studio
Film Roman

production company
Film Roman/Lee Mendelson/United Media

designer
Jim Davis

executive producer
Phil Roman

Traditional cel animation.

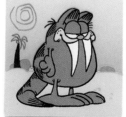
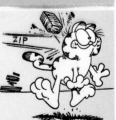

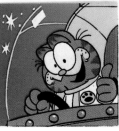

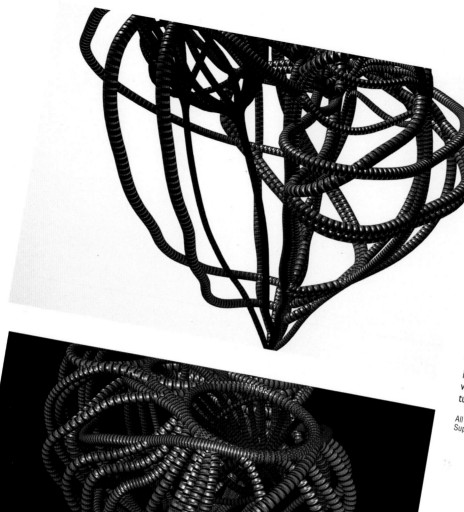

PUMP UP THE VOLUME
SCIENTIFIC
VISUALIZATION

Animation Studio
Pittsburgh Supercomputing Center

Supervisor/Animator
Gregory Foss

Software Support
Grace Giras

Researchers
David McQueen, Charles Peskin, NYU

Software Used
Microsoft Softimage

Hardware Used
Silicon Graphics, Inc. Extreme, and Crimson Reality Engine

The researchers' data was imported into Softimage as splines. The splines were used to build texture mapped tubes.

TORNADO WATCH
SCIENTIFIC
VISUALIZATION

Animation Studio
Pittsburgh Supercomputing Center

Supervisor/Animator
Gregory Foss

Software Support
Grace Giras, Pittsburgh Supercomputing Center

Researchers
Kevin Droegemeier, Ming Xue, C.A.P.S., University of Oklahoma

Software Used
Microsoft Softimage Creative Environment, AVS

Hardware Used
Silicon Graphics, Inc. Indigo 2 Extreme, Silicon Graphics, Inc. Crimson Reality Engine

The researchers' data was visualized in A.V.S. and output as isosurface geometries. Geometry was imported into Softimage for materials, lighting, choreography, and rendering.

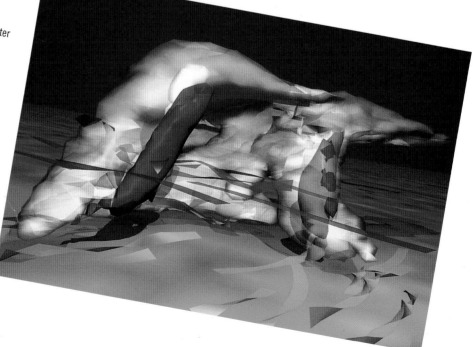

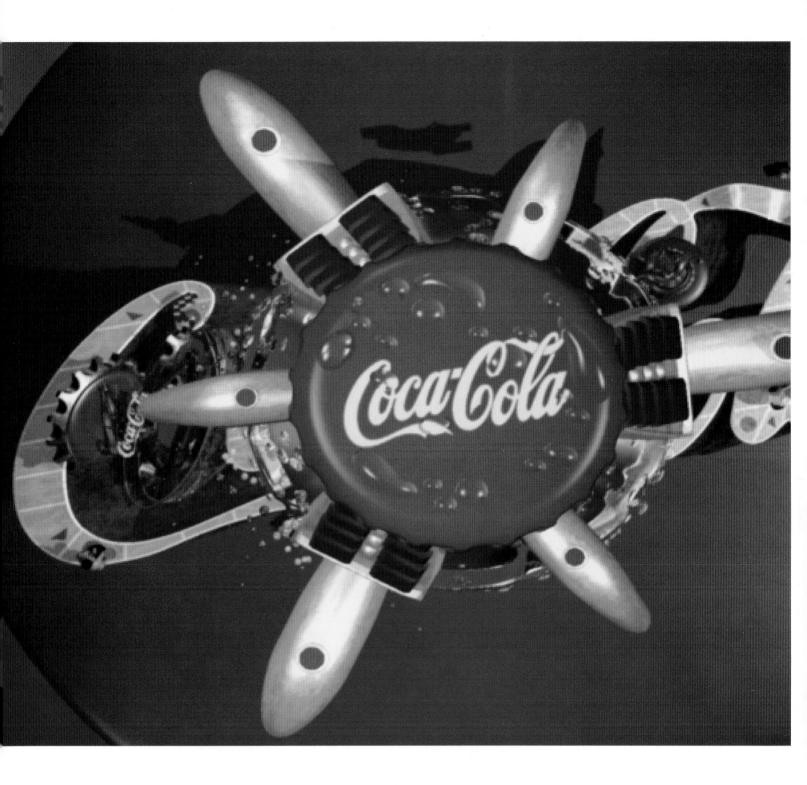

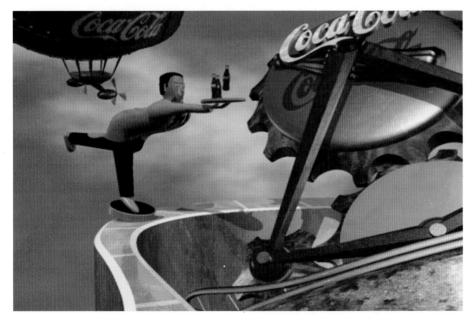

The legendary "Coca-Cola" logo doubles as a rocket ship propeller above, and graces dozens of zany gadgets in the game board world of (Colossal) Picture's *Pictogram*.

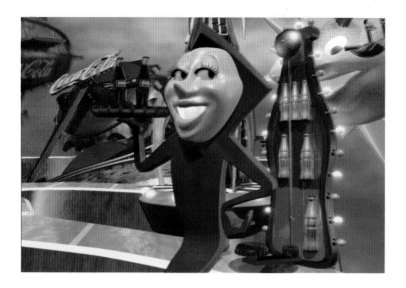

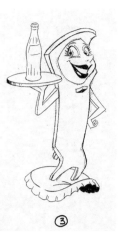

In Colossal Picture's *Pictogram*, a 2-D drawing transforms...

...into a 3-D model.

Surface textures are applied ...

...and details are added.

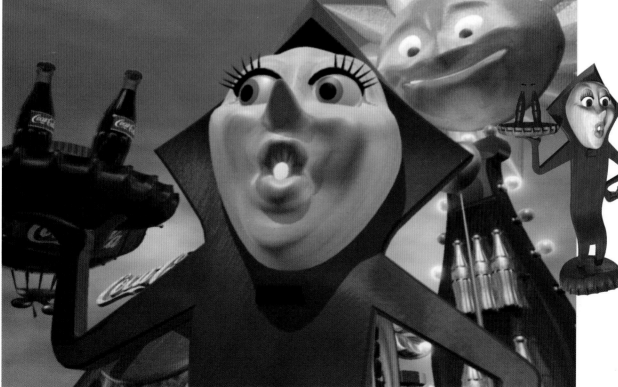

DRAGONSPHERE

Company
Microprose Software

Design Firm
Microprose Software

All Design
Bob Kathman,
Mike Gibson

Graphics for animated
graphic adventures were
hand painted, then
scanned and touched up.

All Artwork ©Microprose Software 1994

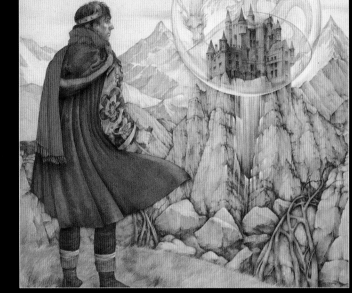

RENEGADE™

Company
Taito

Design Firm
Qually & Company, Inc.

Art Director
Robert Qually

Design
Robert Qually, Karla Walusiak,
Holly Thomas, Charles Senties

Illustrator
Ron Villani

Recognizable characters, and uncomplicated
levels objectives are easily related to comic
book super-heroes and storylines. Simple illus-
tration techniques support the "good vs. evil"
theme.

Objective
This is a fast-paced, real life, street-style
karate action game. The story line involves
a man alone in the subway who encoun-
ters various gang members. Gamers must
fight off these enemies as they approach
with pipes, chains, and their fists.

Taito® and Renegade® are trademarks of Taito America
Corporation. Copyright © 1989.

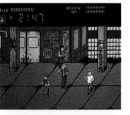

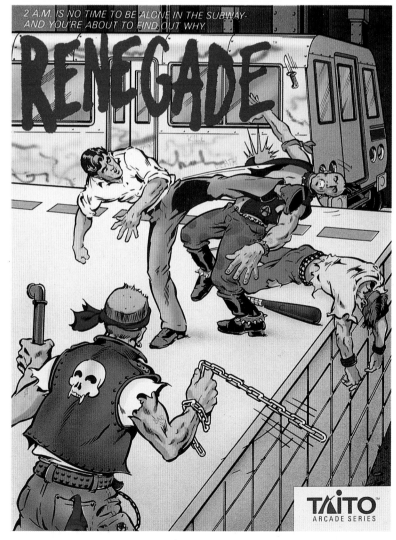

PRELUDE TO EDEN
short film

studio
Michel Gagne

character creator/designer
Michel Gagne

supervisor/animator
Michel Gagne

art director
Barry Atkinson

Film was animated on paper and the backgrounds painted on illustration boards. A 90 mhz Pentium computer and ANIMO and TIFFANY software were used to turned scanned artwork into digital animation.

URL: http://www.qmm.com.au/hon

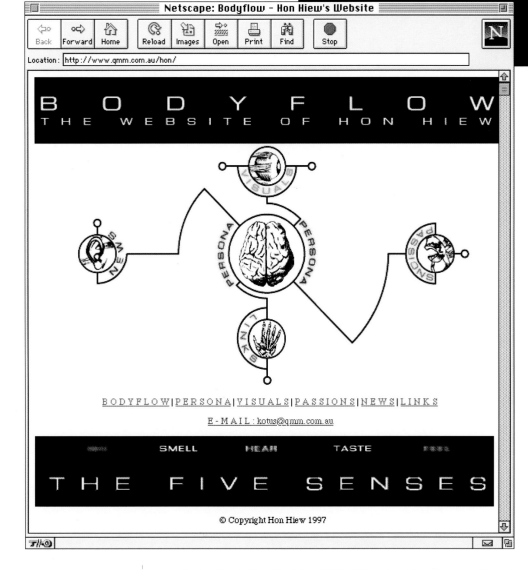

BODYFLOW
THE WEBSITE OF HON HIEW

BODYFLOW|PERSONA|VISUALS|PASSIONS|NEWS|LINKS
E-MAIL : kotus@qmm.com.au

SMELL HEAR TASTE

THE FIVE SENSES

© Copyright Hon Hiew 1997

SELF-PROMOTIONAL

The Bodyflow Website by designer Hon Hiew is characterized by the theme of the five senses, which is used as an organizational metaphor. Each sense maps to an area of Hiew's portfolio—hearing to news, touching to links, sight to his on-line portfolio.

The opening page for each subsection features an anatomical illustration symbolic of each sense. Links to other pages are implemented by image-mapped typography and a navigation bar at the bottom of the page.

Color, simple circular shapes, and unique line treatments are additional elements that combine to unify the design.

Each letter in the "Bodyflow" title (above) rotates along a different axis, either from top to bottom or side-to-side, creating dynamic movement. In the black bar below the home page image each of the senses fades in and out, enlivening an otherwise static area.

Project:
Bodyflow Portfolio

Designer:
Hon Hiew

Features:
GIF89a animation

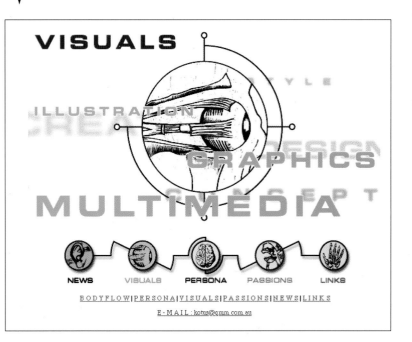

VISUALS

ILLUSTRATION

GRAPHICS

MULTIMEDIA

NEWS VISUALS PERSONA PASSIONS LINKS

BODYFLOW|PERSONA|VISUALS|PASSIONS|NEWS|LINKS
E-MAIL : kotus@qmm.com.au

STEVE SAVES THE UNIVERSE, AGAIN
SHORT FILM

Animation Studio
Space Monkey Productions

Character Creator/Designer
Don Kinney

Supervisors/Animators
Don Kinney, Dreux Priore

Technical Director
Dreux Priore

Directors
Don Kinney, Dreux Priore

Other Personnel
Melissa Polakovic, Shawn Paratto,
Bill Schiffbauer, Celine Schiffbauer

Software Used
Hash, Inc. Animation Master,
Autodesk 3D Studio/Max

Hardware Used
Intel/Windows NT

Gunther was originally designed as
a foam latex puppet character.
The design is very successful as a
computer character.

STEVE SAVES THE UNIVERSE, AGAIN
SHORT FILM

Animation Studio
Space Monkey Productions

Character Creator/Designer
Don Kinney

Supervisors/Animators
Don Kinney, Dreux Priore

Technical Director
Dreux Priore

Directors
Don Kinney, Dreux Priore

Other Personnel
Melissa Polakovic, Shawn Paratto,
Bill Schiffbauer, Celine Schiffbauer

Software Used
Hash, Inc. Animation Master,
Autodesk 3D Studio/Max

Hardware Used
Intel/Windows NT

In "Steve Saves the Universe, Again,"
there is a combination of both highly
realistic and cartoonish characters.
The environments are highly stylized
to create a totally unique look.

JODI.ORG

SELF-PROMOTION

Jodi.org is a programmer/artist Website created by Joan Heemskeerk and Dirk Paesmans. Except on the home page, the site contains no intelligible text for the human eye—visiting this site is equivalent to experiencing what a computer might do for fun (or art) on the Web if freed from human constraints. Screens full of color and energy seem to scroll endlessly. Randomly clicking on a data stream switches the viewer to yet another stream, with different colors and different computer meaning.

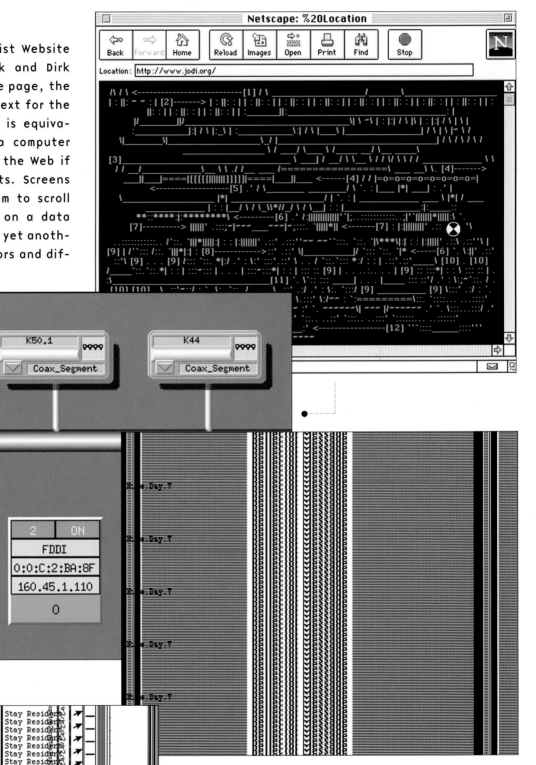

TECHNIQUE: This experimental site uses embedded Java programming to send screen data incredibly rapidly—viewers who are accustomed to slow screen-draw times while surfing the Web will be amazed at how rapidly screens change and scroll in this site. The site moves and pulsates with computer life so rapidly that it seems as though the display originates from the viewer's own hard drive, when in fact it is originating from a site in the Netherlands. The technology behind this site seems to promise a new era on the Web.

Project: Jodi.org

Design: Joan Heemskerk, Dirk Paesmans

Illustrator: Nicholas Wittenberg

Features: Embedded Java

SPACE JAM
INTERACTIVE KIOSK

Animation Studio
CBOmultimedia, div.
Cimarron/Bacon/O'Brien

Client/Agency
Warner Brothers, Denise Bradley,
Bob Bejan

Creative Director
Jill Taffet

Supervisor/Animator
Robert Vega

Director
Jill Taffet

Director of Production
John Peterson

Programmer
Peter Wolf

Digital Artist
Sabrina Soriano

Executive Producer
Robert J. Farina

Software Used
Radius Video Vision, MacroMedia
Director, Adobe After Effects and
Photoshop

Hardware Used
FWB Jack Hammer, FWB Array,
MicroTouch Touch Screen,
Power Macintosh

The Space Jam Interactive Kiosk was
created to promote the new Warner
Bros. movie *Space Jam* prior to its
release. The kiosk interface is a wild
and exciting scene of animated
basketballs that fly out and bounce
at you when selected. The kiosks
previews all the aspects of the movie
showing clips, pencil tests, story
and merchandise.

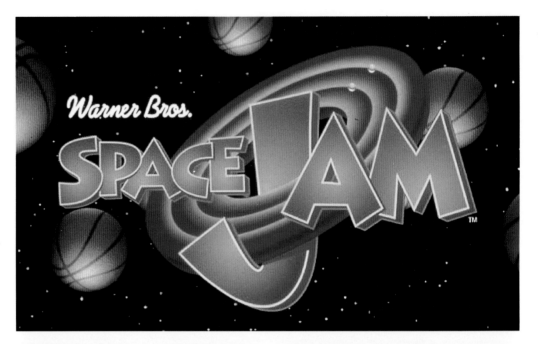

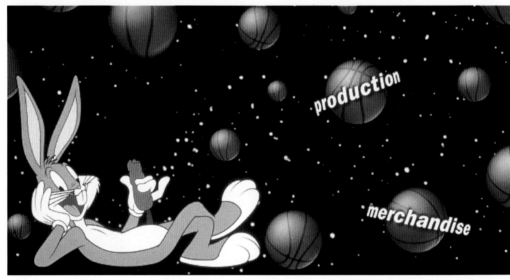

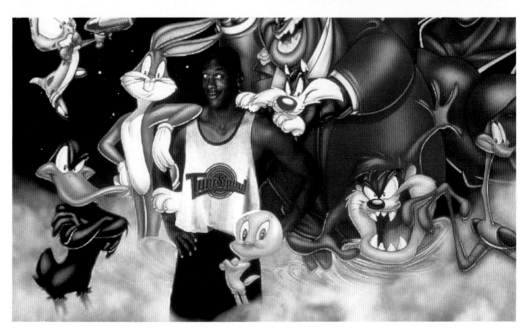

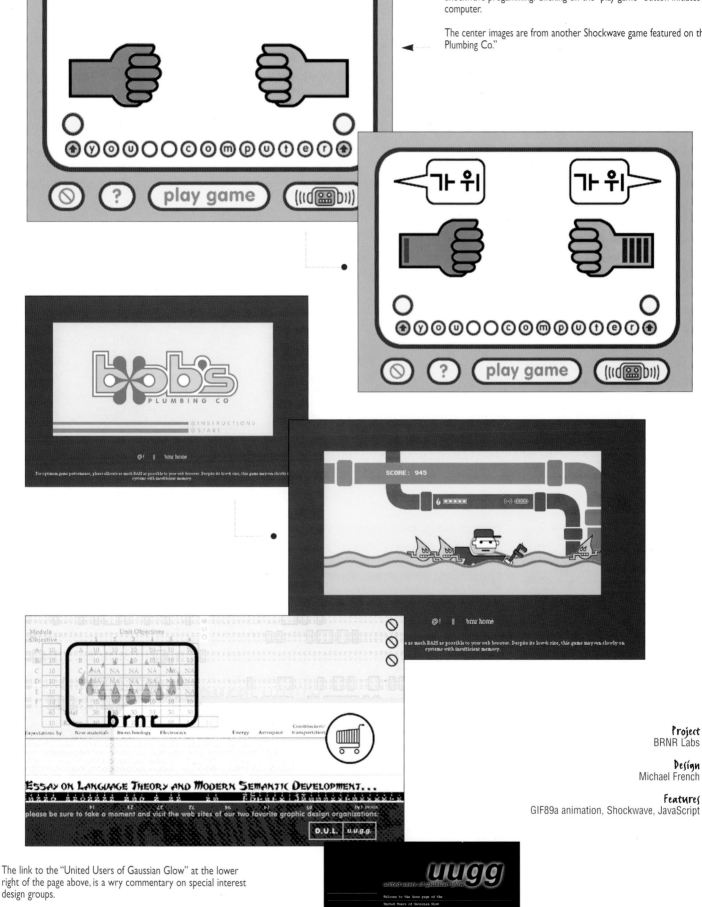

Technique

Programmer/designer Michael French has brought a Korean version of the classic game "Rock-Paper-Scissors" to the Web, complete with strategy and sound, using Shockwave progamming. Clicking on the "play game" button initiates play against the computer.

The center images are from another Shockwave game featured on the sit, "Bob's Plumbing Co."

The link to the "United Users of Gaussian Glow" at the lower right of the page above, is a wry commentary on special interest design groups.

Project
BRNR Labs

Design
Michael French

Features
GIF89a animation, Shockwave, JavaScript

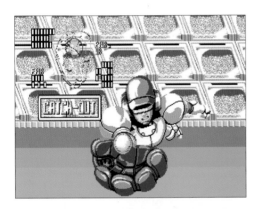

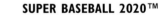

SUPER BASEBALL 2020™

Company
Electronic Arts

Design Firm
13th Floor

Art Director
Nancy Fong, Nancy Waisanen

Designer
Dave Parmley

Illustrator
Marc Ericksen

Package graphics designed to emphasize the speed and fast action of the smash hit arcade game. Airbrush cover illustration was scanned into a Macintosh Computer and manipulated in Adobe Photoshop. Baseball illustration was created in Photoshop. Package graphics and type were assembled in Quark.

2020 Super Baseball is a trademark of SNK Home Entertainment, Inc. ©1993 Electronic Arts.

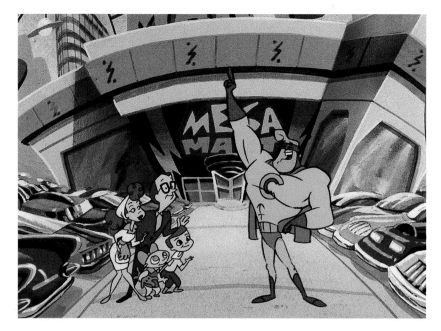

OPENING (ROBOCOP COMMANDER CASH)
animated inserts for live action television series

studio
Bear Spots Inc. © 1994 Robocop Productions Limited
Partnership, courtesy of Skyvision Entertainment

designer
Ken Morresey, Joe Pearson

supervisor/director
Ken Morresey

supervisor/animator
Ken Morresey

art director
Ken Morresey, Joe Pearson

Traditional cel animation.

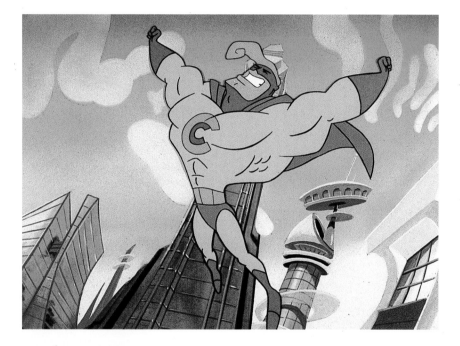

DOG CITY III
animated television series

studio
Nelvana Limited
© 1994 Nelvana Limited (All Rights Reserved)

designer
Jim Henson Productions, Inc.,
Dog City characters ™ & © Jim Henson Productions, Inc.

supervisors/directors
John Van Bruggen/Dave Pemberton

supervisor/animator
Brad Goodchild

line producer
Marianne Culbert

Cel animation and puppet animation.

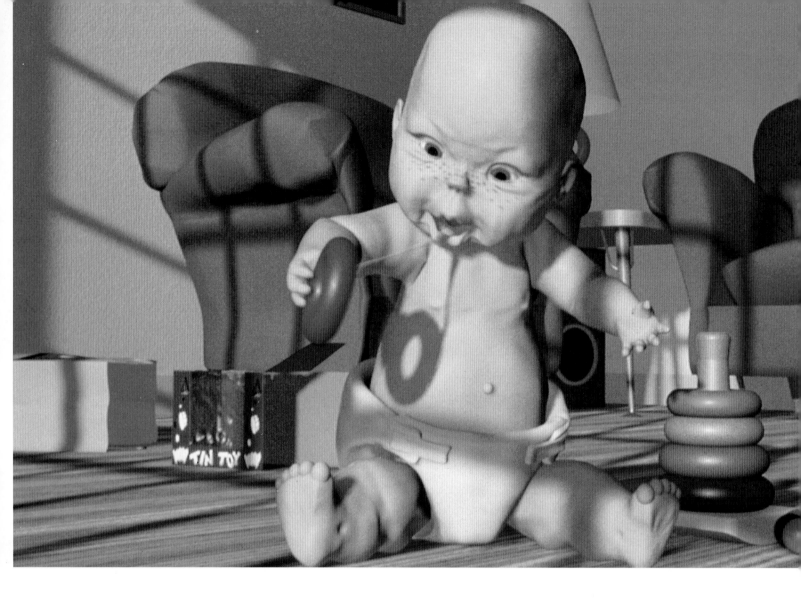

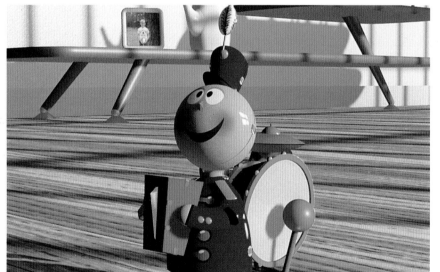

Pixar's *Tin Toy* was the first computer-animated short to win an Academy Award.

Fabric8—a "virtual store"—features unique items created by urban designers. The graphic style of the site reflects the varied and individual styles of the designers showcased in this online shopping environment. Fabric8 designs each of the specific online areas for companies selling their products, trying to convey the look and feel of the company through the use of typography and Web technology such as JavaScript or GIF89a animations.

Netscape: fabric8

Back | Forward | Home | Reload | Images | Open | Print | Find | Stop

Location: http://www.fabric8.com/

june 97

droppin' science: the FAQs

fabric 8

shop pop drop

where independent style is the fashion . . .

no trends here. just a building ground for well-made, unique items from san francisco's underground. feel free to shop, check out a bit of sf style, and get the low-down on fabric8. oh, and please join our mailing list -- we'll be adding more soon. enjoy!

shop pop drop mailing list lin

shop

revolution
ghetto gear for the new millennium

jigowat
modular jewelry from the outer realm

gallo
design studio
fabulous clothing for people of interest

sui generis
hand-crafted everyday we and online fitting room

english 日本語

$ound buys 8
musical delights hand-picked by our aural experts

con$ume
seasonal gift ideas, ideal for anybody (including yourself) any time of the year

shop pop drop mailing list linx

fabric8

badmarsh: "differences" (ubiquity)
copyright © 1997
website credits
comments?

join our mailing list!

Gallo Design Studio, a group of people living the gay 90s in San Francisco, offers hot clothing for people of interest.

it's not about being a man or a woman; it's about being a man and a woman, expressing yourself through genderless fashionable styles

★ paul gallo ★
world renowned fag

ONLINE CATALOG

GHETTO OF THE MIND

SHOCKWAVE MOVIE

MAILING LIST

ONLINE CATALOG

GHETTO OF THE MIND

SHOCKWAVE MOVIE

MAILING LIST

GHETTO OF THE MIND IS OUR OPINION SECTION. CONTRIBUTE YOUR THOUGHTS AND WIN A FREE REVOLUTION T-SHIRT!
CLICK ON IMAGES FOR DETAILS ABOUT THE

MADE IN THE GHETTO

THE WORLD IS A GHETTO

FROM THE BLUES OF ZION PROSPER'S CORE

UNITY

(THESE TWO-COLOR ORIGINAL ILLUSTRATIONS BY NOIZEE ARE SILK-SCREENED ON SHORT-SLEEVE T-SHIRTS. TO CHECK
PAINTINGS (COMING SOON).

Project Fabric8

Client Fabric8 Online Boutique

Design Firm Fabric8 Productions

Design Olivia Ongpin, Antony Quintal

Programming Antony Quintal, Olivia Ongpin, Joe Emenaker

Photography Drea Donio, Keith Ross, Jackie Way

Features GIF89a animation, Shockwave, JavaScript, Java, Beatnik

[**http://www.fabric8.com**]

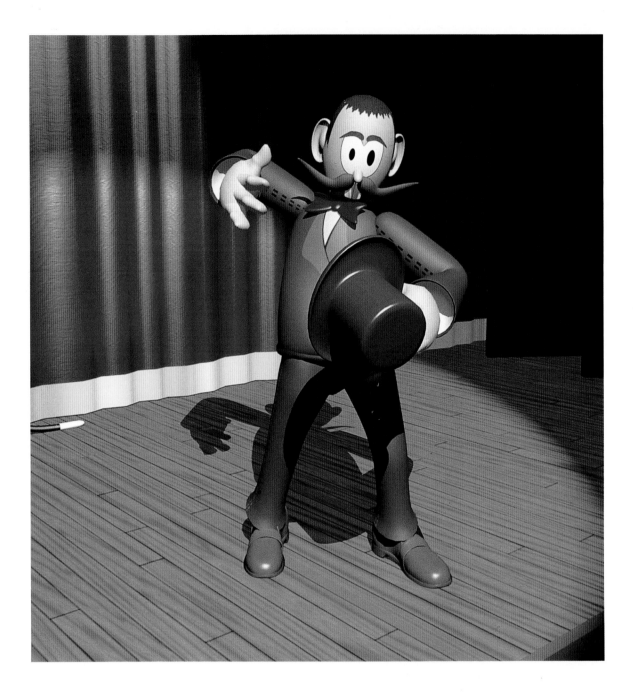

DIABLOTICA
SHORT FILM

Animation Studio
National Animation and
Design Centre

Character Creator/Designer
Dave Lajoie

Supervisor/Animator
Dave Lajoie

Technical Director
Robin Tremblay

Director
Dave Lajoie

Software Used
Microsoft Softimage

Hardware Used
Silicon Graphics, Inc., Extreme

©Centre NAD

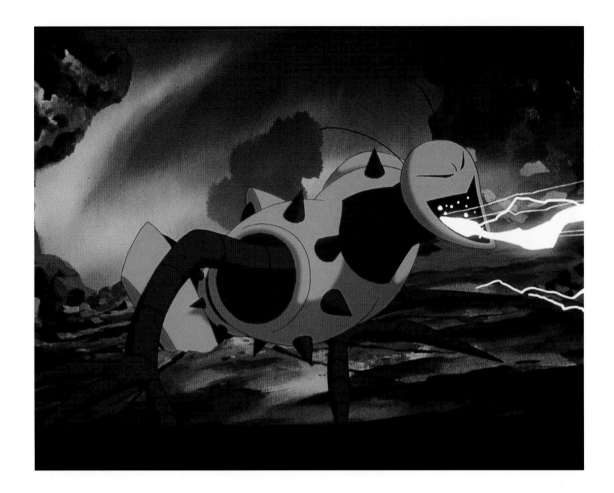

PRELUDE TO EDEN
short film

studio
Michel Gagne

character creator/designer
Michel Gagne

supervisor/animator
Michel Gagne

art director
Barry Atkinson

Film was animated on paper and the backgrounds painted on illustration boards. A 90 mhz Pentium computer and ANIMO and TIFFANY software were used to turned scanned artwork into digital animation.

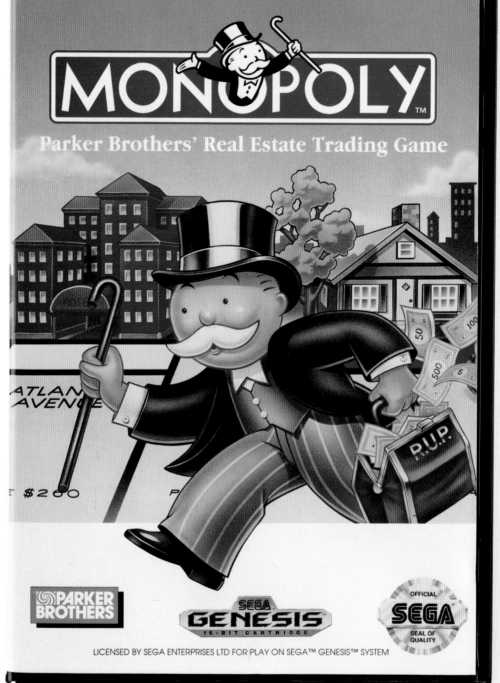

MONOPOLY®
SEGA™

Company
Parker Brothers

Art Director
Jim Engelbrecht

Illustrator
John Hamagami

The use of a traditional illustration was a conscious choice to best illustrate Monopoly and Rich Uncle Pennybags — and to give the package new dimension and to set it apart from the traditional board game.

MONOPOLY® and the game board design are Tonka Corporation's registered trademarks for its real estate trading game and game equipment.

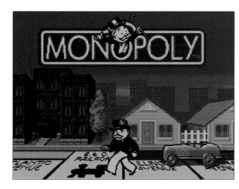

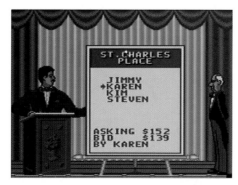

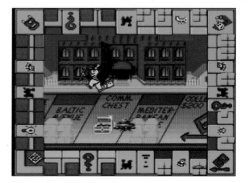

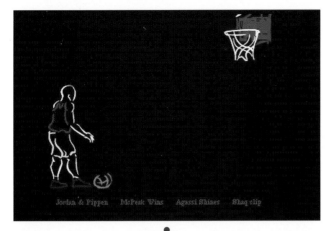

Technique
The designer wanted to create a very visually intensive, rather than text-intensive, Website. To achieve this, they present material in a non-scrolling environment, similar to a CD-ROM interface. The GIF89a animation of the slam-dunking basketball player links form the main sports area below.

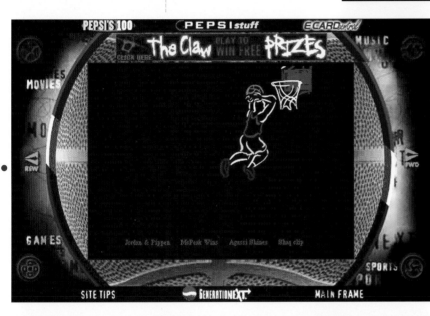

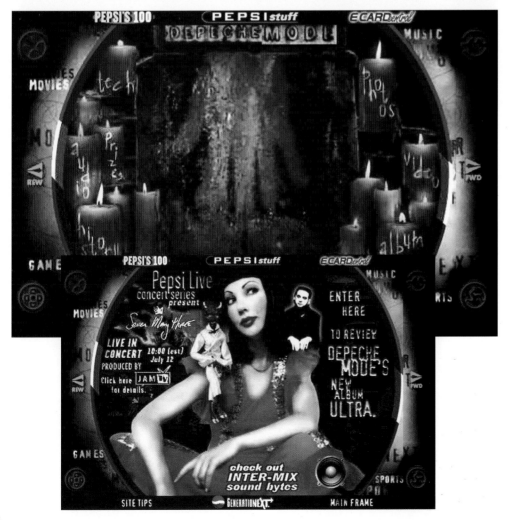

Project
Pepsi World

Client
Pepsi Co.

Design Firm
DDB Interactive

Design
Chris Hess, Frances Ko, Mike Gonzales, Tricia Elliot

Photography
Jill Green

Programming
Thomas Jeffry, Shelley Shay, Sal Torneo

Features
GIF89a animation, Shockwave Flash, Java, RealAudio, RealVideo, VRML, QuickTimeVR

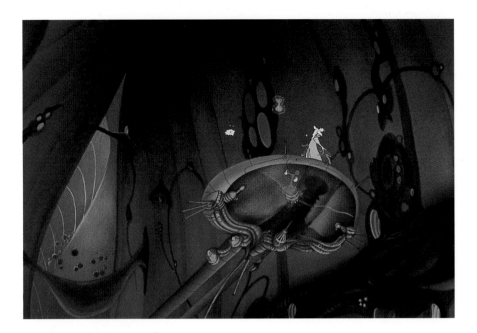

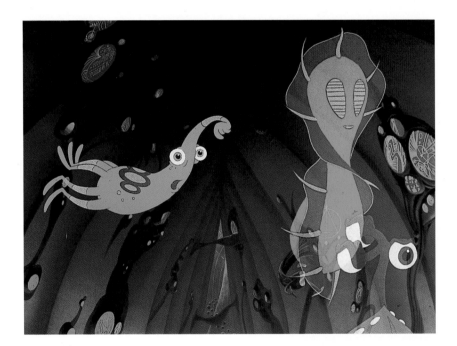

**JOURNEY TO THE PLANETS,
SHORT FILM**
(theatrical Omnimax presentation)

studio
Bear Spots Inc.

designer
Frank Nissen

supervisor/director
Clive Smith

supervisor/animator
Gary Hurst

art directors
Frank Nissen, Clive Smith

producers
Graeme Ferguson, Toni Myers, Imax
Corporation

Cel animation composited with live action
animation.

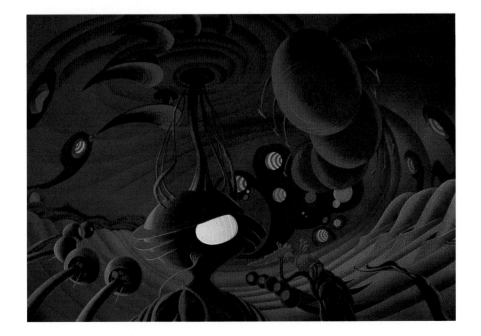

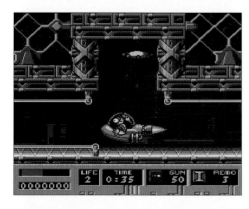

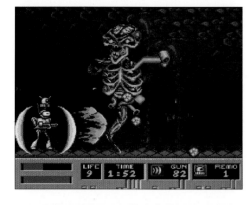

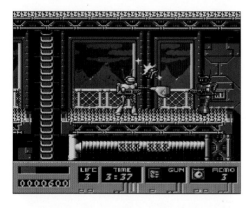

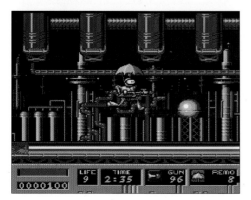

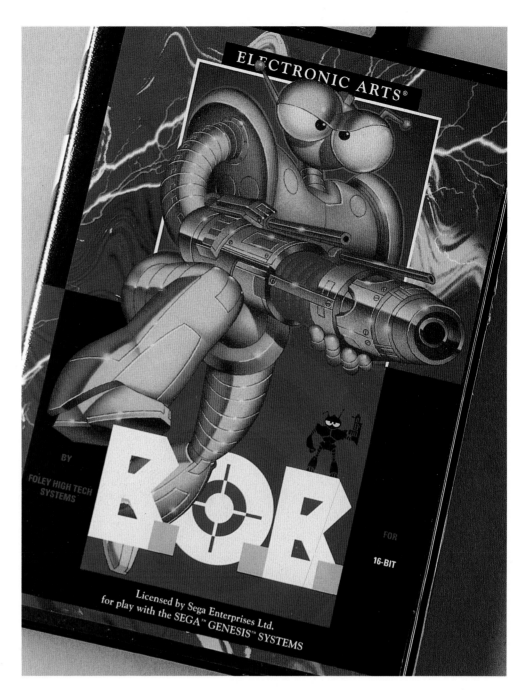

B.O.B.

Company
Electronic Arts

Design Firm
13th Floor

Art Director
Nancy Fong, Nancy Waisanen

Designer
Dave Parmley

Illustrator
Marc Ericksen

Computer Production
Stover Pix

Package graphics feature a friendly super robot hero that breaks the modular border design. Artwork created in Aldus Freehand and Adobe Photoshop. Cover and back graphics and type were assembled in Quark.

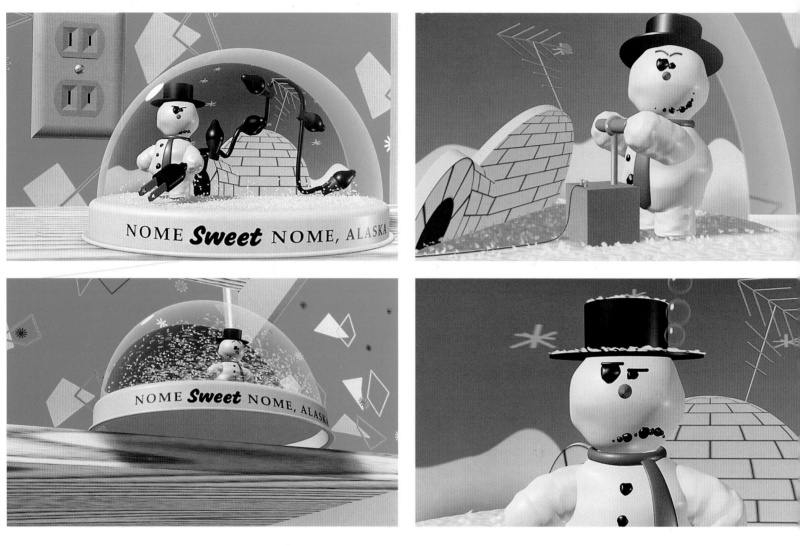

It's a little known fact that Pixar's *Knickknack* is actually a stereoscopic film.

The Adventures of André & Wally B—1984

Luxo Jr.—1986 (Oscar Nomination, Best Animated Short Film)

Red's Dream—1987

Tin Toy—1988 (Oscar, Best Animated Short Film)

Knickknack—1989

 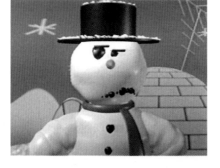 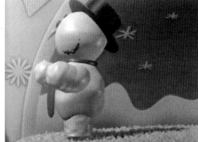

 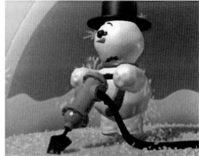

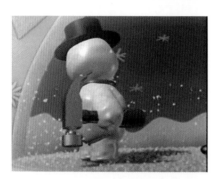 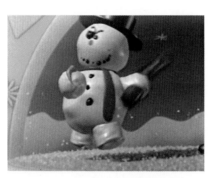

After our hero catches a glimpse of the buxom plastic doll sitting on a "Sunny Miami" ashtray nearby, he is determined to find a way out of his plastic prison. As you can see, his methods become extreme.

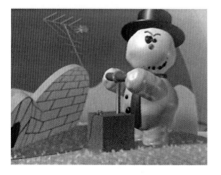

SHELL OIL DANCE FEVER

Animation Studio
R/Greenberg Associates

Client/Agency
Ogilvy & Mather, Houston

Computer Graphics Animators
Fred Nilsson, Steve Blakey, Edip Agi

Technical Director
Sylvain Moreau

Computer Graphics Director
Mark Voelpel

Computer Graphics Designer
Sylvain Moreau

Software Used
Microsoft Softimage, R/GA
proprietary software, Imrender

Hardware Used
Silicon Graphics, Inc.

R/GA and director David Lane of Savoy
Commercials used dancers for visual
reference. A playful interpretation of
human dance motion was constructed
entirely in computer graphics on Silicon
Graphics workstations, using 3-D mod-
els from Viewpoint DataLabs; Microsoft
Softimage 3-D; and Imrender, R/GA's
proprietary software.

"Dance Fever" :30, ©Shell Oil 1995. Courtesy of
R/Greenberg Associates, N.Y. and Ogilvy &
Mather, Houston.

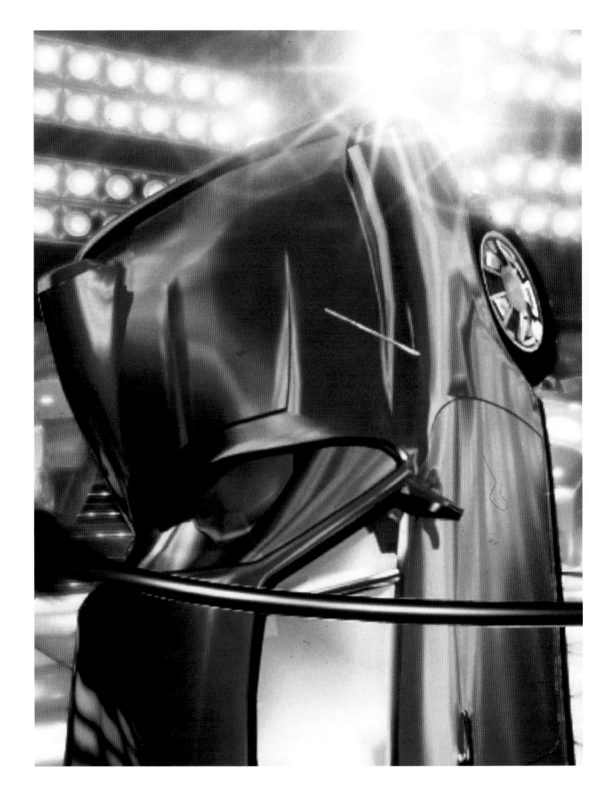

SHELL OIL CHICAGO BLUES

Animation Studio
R/Greenberg Associates

Client/Agency
Ogilvy & Mather, Houston

Computer Graphics Animators
Doug Johnson, Sean Curran, Steve Mead, Fred Nilsson, Steve Blakey, Edip Agi

Technical Director
Sylvain Moreau

Computer Graphics Director
Mark Voelpel

Computer Graphics Designers
Sylvain Moreau, Irene Kim

Software Used
Microsoft Softimage, R/GA Proprietary Software, Imrender

Hardware Used
Silicon Graphics, Inc.

The creators used dancers for visual reference, from which the motion was constructed entirely in computer graphics. Miniatures were created and then married in R/GA's D-1 component digital video suite. R/GA's special effects editors created a seamless composite of 220 separate layers in the final composite.

"Chicago Blues" :30, ©Shell Oil 1995. Courtesy of R/Greenberg Associates, N.Y. and Ogilvy & Mather, Houston.

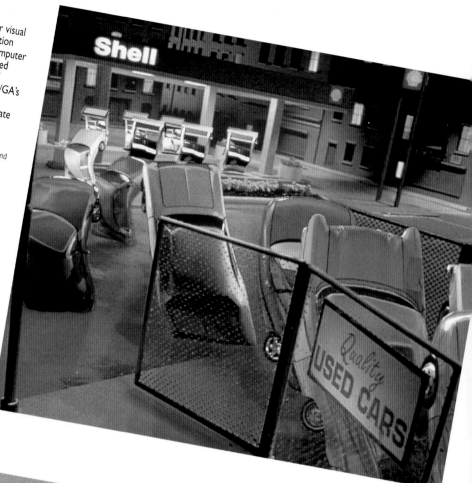

SHELL OIL LIMBO

Animation Studio
R/Greenberg Associates

Client/Agency
Ogilvy & Mather, Houston

Computer Graphics Animators
Doug Johnson, Sean Curran, Steve Mead, Fred Nilsson, Edip Agi

Technical Director
Sylvain Moreau

Computer Graphics Director
Mark Voelpel

Computer Graphics Designer
Sylvain Moreau

Software Used
Microsoft Softimage, R/GA Proprietary Software, Imrender

Hardware Used
Silicon Graphics, Inc.

The motion of the vehicles was created in computer graphics, but dancers were used for reference. The final composite consisted of 220 layers combined by R/GA's special effects editors.

"Limbo" :30, ©Shell Oil 1995. Courtesy of R/Greenberg Associates, N.Y. and Ogilvy & Mather, Houston.

PACIFIC DATA IMAGE'S CHROMOSAURUS

An exercise in fluid character motion, *Chromosaurus* was a groundbreaking short-short that helped Pacific Data Images prove computer animation was good for more than flying logos.

PACIFIC DATA IMAGE'S BRIC-A-BRAC

Although *Bric-a-Brac* looks like a traditionally animated cartoon, no pencils were used to make this strictly digital creation.

PACIFIC DATA IMAGE'S OPERA INDUSTRIEL

In this short-short, highly realistic backgrounds create an oppressive mood. Faceless slave robots, working in an enormous factory setting, portray feelings of hopelessness through subtle head and shoulder movements.

Images ©Pacific Data Images

PACIFIC DATA IMAGE'S GAS PLANET

This award-winning short film was produced in 1992 to test the company's ability to create entertaining and engaging characters in a painterly style that was an unusual stretch for the medium at the time.

PACIFIC DATA IMAGE'S LOCOMOTION

This research and development project offers fun proof that a computer-animated character—in this case a little steam engine—can actually show emotions without relying on facial features such as eyebrows, lips, etc.

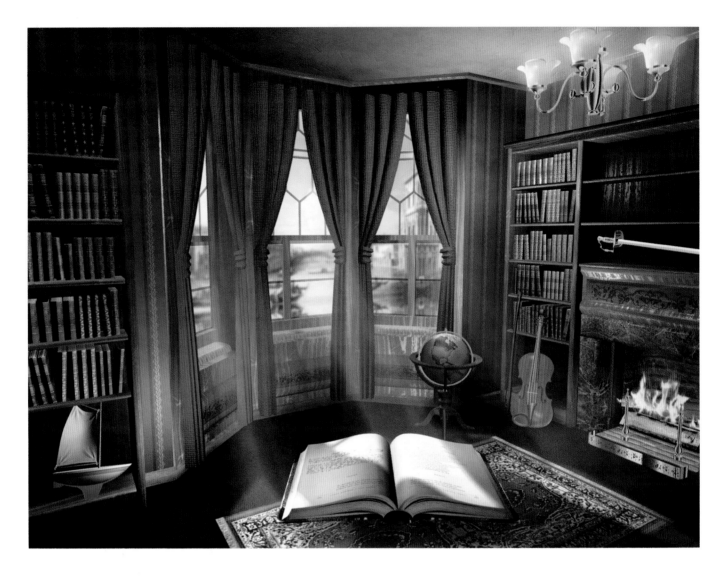

THE EINSTEIN
VIRTUAL WORLD

Animation Studio
Dawson 3-D, Inc.

Character Creator/Designer
Henk Dawson

Supervisor/Animators
Henk Dawson

Art Director
Maz Kessler (Microsoft)

Software Used
auto•des•sys Inc. form•Z,
ElectricImage Animation System,
Adobe Photoshop

Hardware Used
Macintosh

The animator researched and
sketched three scenes: the
observatory, modeled on the one at
University of Washington; a home
office, modeled on Einstein's; and a
patent office, modeled on the one in
which Einstein worked. Many hours
were spent picking out textures and
setting the lights. All the scenes were
rendered and animated in
ElectricImage.

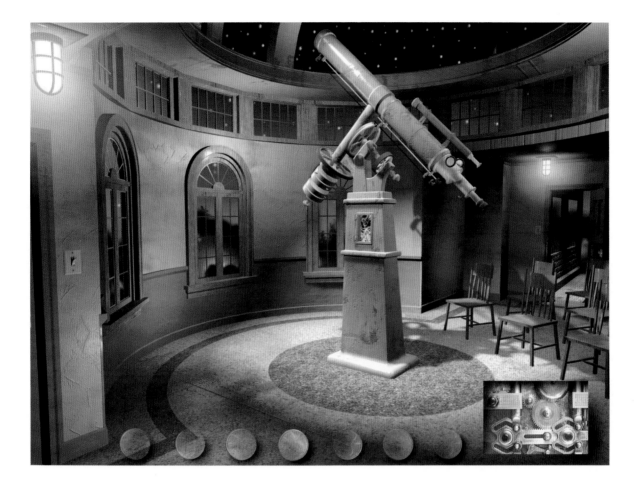

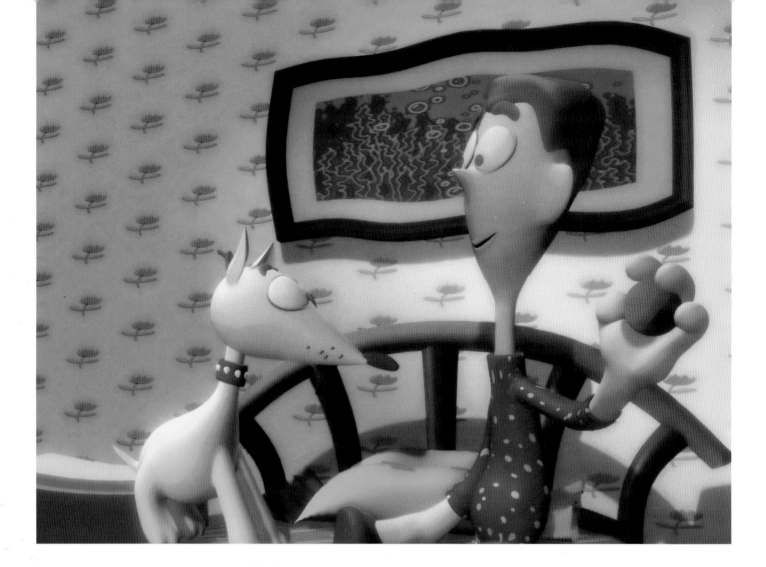

In a shot sequence for
Sleepy Guy, by Raman Hui,
Sleepy Guy throws a ball
out an open upper-story
window. His faithful, yet
very annoying dog chases
right after it.

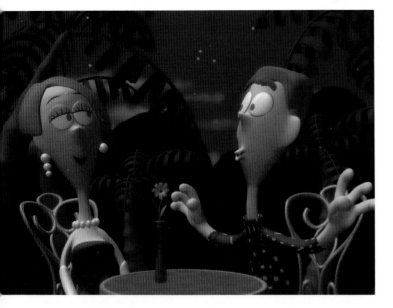

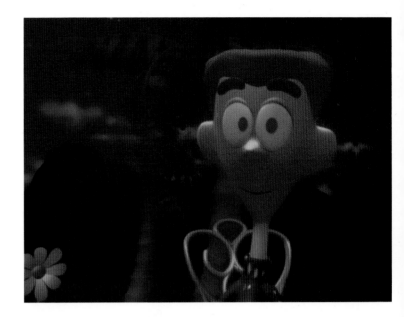

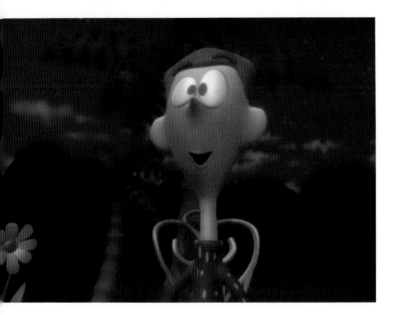

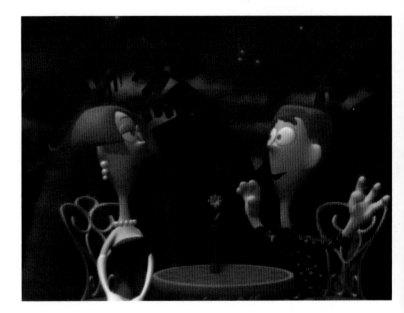

Scenes that included shots of Sleepy Guy and his girlfriend required some inspired guesswork. Says Hui, "With hand-drawn animation, it's no trouble to have two characters in the same scene—you just draw them in. With computer animation you can animate them together but it takes a lot of computing power, so the process is painfully slow. It's easier to animate one first—like the character that leads the action—save that, and then go back and do what we call a calculation of the animation with the motion you've done—just a simple animation of the lead as a reference for the other character's animation. Then you render the scene and see if they fit together. You can get pretty close, but you always have to go back and make adjustments."

Hui put in some long hours manipulating the movements of Sleepy Guy so that they appeared smooth and pliable (like a bendable, plastic doll) rather than hard and stiff—a characteristic he found annoying in a great deal of computer animation at the time.

In the dreams of Raman Hui's *Sleepy Guy*, he tries to make a good impression on his girlfriend in the hopes of stealing the perfect kiss.

DREAMSTATE

SELF-PROMOTION

The Dreamstate site shows an experiment in typography and drama by designer Josh Feldman of Prophet Communications. The premise of the piece was to create a film without actors, sets, or sound, using only animated type to convey action, emotion, and intelligence. For instance, where sound and music are used to evoke emotions in film, in Dreamstate this is accomplished by subtle overtones of moving color.

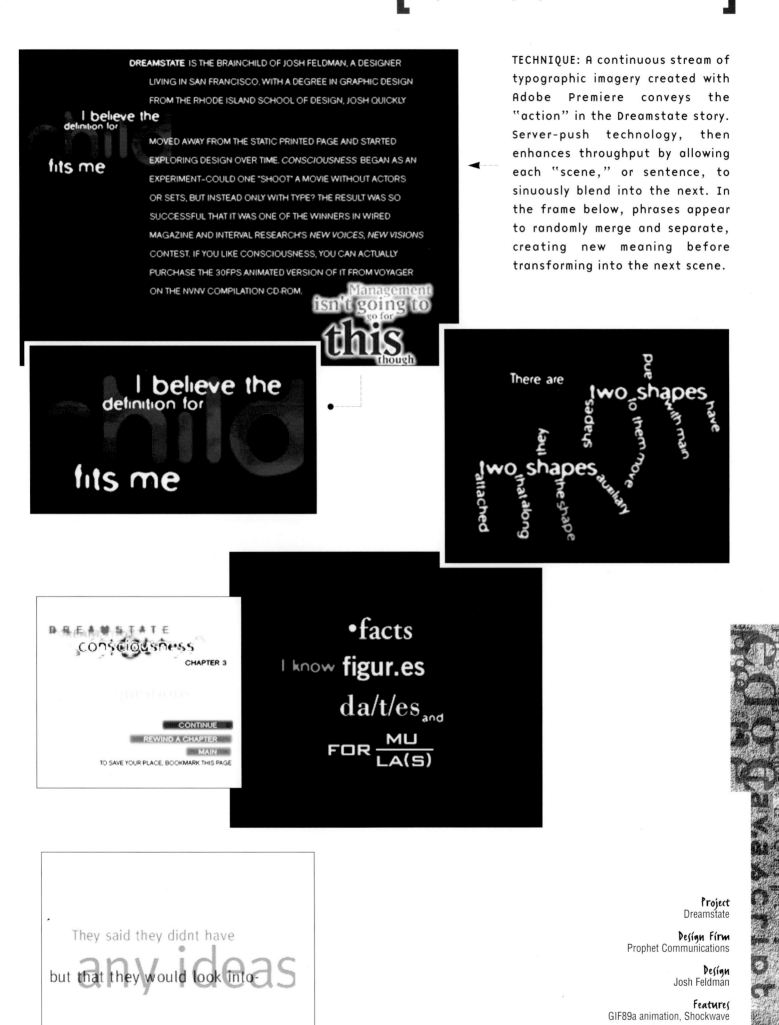

DREAMSTATE IS THE BRAINCHILD OF JOSH FELDMAN, A DESIGNER LIVING IN SAN FRANCISCO. WITH A DEGREE IN GRAPHIC DESIGN FROM THE RHODE ISLAND SCHOOL OF DESIGN, JOSH QUICKLY MOVED AWAY FROM THE STATIC PRINTED PAGE AND STARTED EXPLORING DESIGN OVER TIME. CONSCIOUSNESS BEGAN AS AN EXPERIMENT-COULD ONE "SHOOT" A MOVIE WITHOUT ACTORS OR SETS, BUT INSTEAD ONLY WITH TYPE? THE RESULT WAS SO SUCCESSFUL THAT IT WAS ONE OF THE WINNERS IN WIRED MAGAZINE AND INTERVAL RESEARCH'S NEW VOICES, NEW VISIONS CONTEST. IF YOU LIKE CONSCIOUSNESS, YOU CAN ACTUALLY PURCHASE THE 30FPS ANIMATED VERSION OF IT FROM VOYAGER ON THE NVNV COMPILATION CD-ROM.

TECHNIQUE: A continuous stream of typographic imagery created with Adobe Premiere conveys the "action" in the Dreamstate story. Server-push technology, then enhances throughput by allowing each "scene," or sentence, to sinuously blend into the next. In the frame below, phrases appear to randomly merge and separate, creating new meaning before transforming into the next scene.

Project
Dreamstate

Design Firm
Prophet Communications

Design
Josh Feldman

Features
GIF89a animation, Shockwave

75

ALCON™

Company
Taito

Design Firm
Qually & Company, Inc.

Art Director
Robert Qually

Design
Robert Qually, Karla Walusiak, Holly Thomas, Charles Senties

This simple and clean, yet futuristic game was created through pen and ink illustration and photo-images. Special effects such as abstract paintings, colored lights, and electronic microscopic photographs, helped to form the planet, city, and foreground design.

Objective
The Allied League of Cosmic Nations choose the gamer to pilot the top secret SW475 Starfighter in order to stop the alien occupation of the planet, Orac. To reclaim the planet, gamers must destroy the alien enemy once and for all.

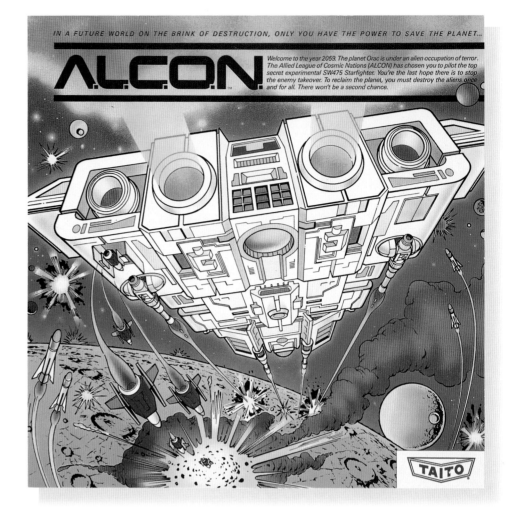

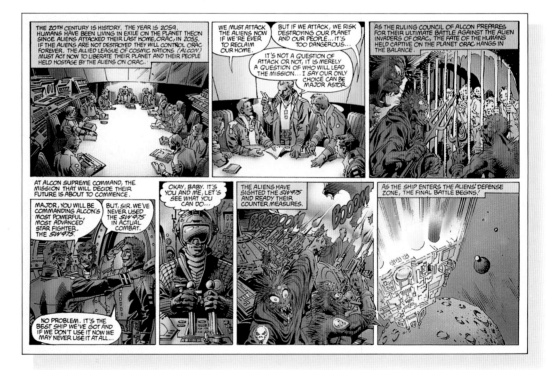

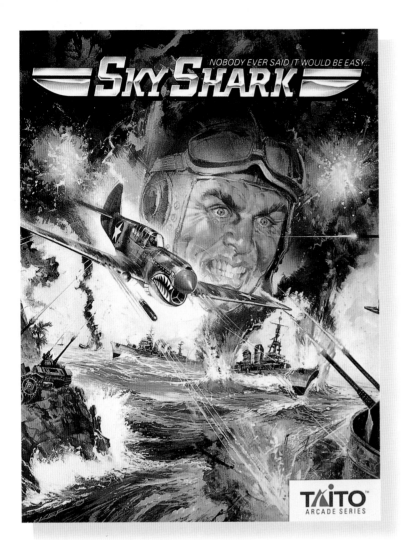

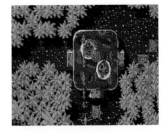

SKY SHARK™

Company
Taito

Design Firm
Qually & Company, Inc.

Art Director
Robert Qually

Designer
Robert Qually, Karla Walusiak, Holly Thomas, Charles Senties

Illustration
Don Kusker

The authentic design of a P-40 plane, along with Air Force pilot's wings, bring the gamer back in history. The screen shots use brighter color combinations, giving the game an optimistic, more inspirational feel than other, more ominous games.

Objective
Sky Shark takes its players into a full force, World War II battle in the skies. Gamers are the Shark, the best pilot in the squadron, and must enter into enemy territory to save a fallen group of airmen from a terrible fate.

Taito® and Sky Shark® are trademarks of Taito America Corporation. Copyright © 1989.

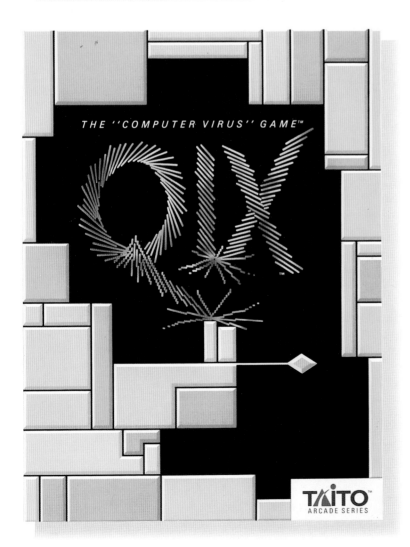

QIX™

Company
Taito

Design Firm
Qually & Company, Inc.

Art Director
Robert Qually

Designer
Robert Qually , Karla Walusiak, Holly Thomas, Charles Senties

Illustration
Ron Villani

This game's original form is the rectangular box shape, not an album shape as with other packages. The Qix is represented by a rainbow helix that actually spells out QIX in its shape. The use of fluorescent colors on a black screen gives a spontaneous look to the image, while the Qix-trapping squares made with rubylithe-type film on acetate bring the rainbow helix to life.

Taito® and QIX® are trademarks of Taito America Corporation. Copyright © 1989.

SNOWBOUND

Animation Studio
Olive Jar Studios

Client/Agency
The Southland Corporation,
J. Walter Thompson (Chicago)

Creative Director
Fred MacDonald

Supervising Animator
Rich Ferguson-Hull

Technical Director
Bryan Papciak

Directors
Fred MacDonald, Rich Ferguson-Hull, Bryan Papciak

Producer
Jim Moran

Executive Producer
Matthew Charde

Hardware Used
Quantel Henry

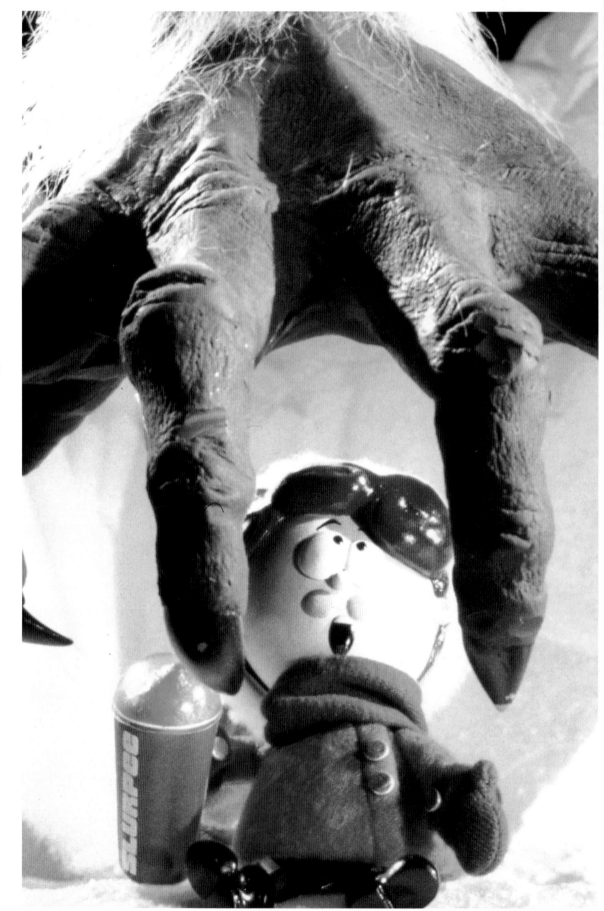

The ride-simulation film, *Superstition*,
takes guests through the haunts of an
abandoned theme park, an attraction
that is definitely not for the faint
of heart.

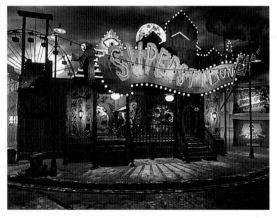

For more work by these designers and others, please
see the following titles, also by Rockport Publishers:

The Best New Animation Design
The Best New Animation Design, by Rita Street
Computer Animation, by Rita Street
Cutting Edge Web Design, by Daniel Donnelly
Game Graphics
In Your Face, by Daniel Donnelly
Upload, by Daniel Donnelly
WWW Design, by Daniel Donnelly